Dedication

This book is dedicated to all the individuals who inspire creativity in you.

To my wife, Janet

who continues to foster patience, understanding and priority in my life and my work
and who inspires and motivates the children in her classroom in ways I can only dream of.

To my daughter, Katy

born on the first day of spring (and somewhere around chapter two),
whose smile keeps my brain and heart in motion.

To the talented people of Mark Oldach Design–

Christine, Don, Mark, Jennifer and Dian–

who support, inspire, motivate and challenge me on a daily basis.

Acknowledgments

From the first time we talked about his book, Mary Cropper had an insight into the subject of creativity and the trust in me as an author that exceeds reasonable. As the editor, Mary challenged me in the same ways that I challenge my clients, and added the element of gravity to an otherwise lofty subject. Equally as trusting and supportive were the production editors, Terri Boemker and Roseann Biederman and the designers who worked on this book, Clare Finney and Sandy Conopeotis.

My moments of frustration and periods of uncertainty were diluted by the support and inspiration of Christine MacDonald. Christine assisted in ways even she is unaware of. Her keen insight, creative wordsmithing and sheer dedication kept me going throughout this project. Don Emery, Mark Meyer and Jennifer Wyville, whose work you also see in the pages of this book, continue to be the fuel for creativity within Mark Oldach Design and the inspiration for this book.

Above all, the creative professionals who offered their words and their work to serve as example, inspiration and motivation are gratefully acknowledged. Their contributions validate and reinforce the thoughts expressed in this book and practiced by many in the creative professions. These individuals are:

Jack Anderson, Hornall Anderson Design
Dana Arnett, VSA Partners
Guy Billout
Kristie Clemons, Gerhardt & Clemons
Scott Clum, Ride Design
Vittorio Costarella, Modern Dog
John Coy, COY Los Angeles
Rick Eiber, Rick Eiber Design (RED)
Maria Grillo, VSA Partners
Alexander Isley, Alexander Isley Design

Diti Katona, Concrete Design Communications
Todd Lief
Anthony Ma, Tanagram
James Miho
Clement Mok, Clement Mok designs
Jennifer Morla, Morla Design
Robert Petrick, Petrick Design
Mark Schwartz, Nesnadny & Schwartz
Rick Tharp, Tharp Did It
Steve Tolleson, Steve Tolleson Design

Table of Contents

Creativity

for Graphic Designers

THE SURREY INSTITUTE OF ART & DESIGN

A REAL-WORLD GUIDE

TO IDEA GENERATION—

FROM DEFINING YOUR MESSAGE TO

SELECTING THE BEST IDEA

FOR YOUR PRINTED PIECE

Mark Oldach

NORTH LIGHT BOOKS
CINCINNATI, OHIO

About the Author

Mark Oldach is founder and president of Mark Oldach Design, Ltd., a nationally recognized communications design firm in Chicago, Illinois. He and his design staff work with a diverse group of clients including Caterpillar, Inc., Northern Trust Bank, Steppenwolf Theatre, Lettuce Entertain You Restaurants, and the Museum of Science and Industry, Chicago. Prior to opening his design firm in 1989, he served as creative director for the American Medical Association. Mark is a graduate of Carnegie-Mellon University in Pittsburgh, Pennsylvania. He is honored, exhibited and published nationally with his firm's work appearing in *Communication Arts, ID Magazine*, ACD 100 Show, *AIGA Communications Graphics, Graphis, Print, HOW*, and the Type Directors Club. He has served on the Board of Directors and Executive Committee for the American Center for Design and, in 1989, was named Fellow of the American Center for Design.

Creativity for Graphic Designers

Published by North Light Books, an imprint of F&W Publications, Inc., 1507 Dana Avenue, Cincinnati, Ohio, 45207. (800) 289-0963. First paperback edition 2000.

Other fine North Light Books are available at your local bookstore, art supply store or direct from the publisher.

04 03 02 01 5 4 3 2

Library of Congress has catalogued hard copy edition as follows:

Oldach, Mark.
 Creativity for graphic designers / by Mark Oldach. -- 1st ed.
 p. cm.
 Includes index.
 ISBN 0-89134-583-3 (hard cover)
 1. Graphic arts — United States — Design. 2. Graphic arts — United States — Marketing. I. Title.
NC1001.043 1995
741.6--dc20 94-38937
 CIP
ISBN 1-58180-055-X (pbk: alk. paper) 334517

Edited by Mary Cropper and Lynn Haller
Designed and Illustrated by Mark Oldach
Cover Design by Clare Finney with Mark Oldach

The permissions on page 138 constitute an extension of this copyright page.

METRIC CONVERSION CHART		
to convert	*to*	*multiply by*
inches	centimeters	2.54
centimeters	inches	0.4
feet	centimeters	30.5
centimeters	feet	0.03
yards	meters	0.9
meters	yards	1.1
sq. inches	sq. centimeters	6.45
sq. centimeters	sq. inches	0.16
sq. feet	sq. meters	0.09
sq. meters	sq. feet	10.8
sq. yards	sq. meters	0.8
sq. meters	sq. yards	1.2
pounds	kilograms	0.45
kilograms	pounds	2.2
ounces	grams	28.4
grams	ounces	0.04

741.6 OLD
7OL

CHAPTER THREE

Growing Ideas

Introduction

. .

Read me.
I am not just a picture book.

It's easy to say that good design is determined by good designers. But there is more to good design than that. How does control of the creative process determine creative design? What role does a great client play? How much is instinct? How much is style? What is style, anyway? Can design be creative around boring words or bad images? None of these elements alone determines creative design; instead they collectively influence ideas.

It is a common practice among designers, especially young designers, to look for inspiration for their own designs from other designers and their work. Although someone's solution to a particular communications problem may spark a unique solution to another's problem, the practice of turning to other designers' work for ideas also influences an inappropriate pursuit of style and trend that can ultimately undermine the substance and purpose of design.

Creativity, real creativity, in design causes a communication to be noticed and understood. But creativity is not found in the style of, or techniques employed for, a communication. It is found in the very center of each communication—the problem it must solve, the objectives and the client. You can find more sources of inspiration in objectives and research than you will find in the work of other designers, no matter how talented, creative or successful they are.

Brainstorming techniques, evaluating the objectives, and alternative methods of visualization will guide you to a unique and appropriate solution for every project. And once you have found that solution, working effectively with the client, writers, image makers and others who help you produce the piece ensures that your vision is sustained—and the project's objectives creatively met—throughout the entire developmental process.

It is my hope that this book will inspire you and guide you to the vast realm of sources of inspiration and ideas. In it we'll explore how creative communication design evolves from information about the project and the client, alternative ways of looking at that information, and sustaining a focus on the details of that communication—whether it is poster, letterhead, brochure or multimedia—to form a truly inspired design. We'll look at the areas of design that you can't see in an annual—sources of creativity, changes of point of view or use of metaphor, and tools for pushing ideas. We'll also explore projects from a variety of very creative designers in depth.

I intended for this book itself to be inspirational. Skim it. Read it from cover to cover. View it as a picture book, a guide book and a sketch book. I hope you will read and reread it, finding it inspirational each time you open it.

Writing this book has been an enlightening experience. You see, trying to isolate what influences creative design is like trying to isolate a drop of water in the ocean. Creativity is so interwoven into the design process that I found myself describing concepts, approaches, phases and methods rather than creativity itself. But creativity is not an isolated process. It doesn't have three phases—as it may appear from this book's table of contents—nor does it have a set of tools. It is a mindset.

The creative mindset is controlled by passion and commitment. It has its own set of alarms that warns you when you start moving off-track. The alarm goes off when the client begins to influence the message or the form of the message in ways that you know contradict the objectives. An alarm goes off when a printer tries to tell you that this other paper is just as good as the one you specified—and it's also cheaper. An alarm goes off when you look at the results of forcing a style you like but which is inappropriate for your audience. And an alarm goes off when you see that the audience has no need for the communication that you are being asked to create. How you act upon and react to these various alarms is part of your individual creativity.

This book is a confirmation that all designers can think creatively and design creative communications. Each designer works differently and is stimulated and motivated by different things, as you'll see in the case studies throughout this book. But each fits into the entire creative process you'll explore here—more than just coming up with ideas, it's fertilizing, pruning, ripening and harvesting them.

Preparing for Ideas

IF YOU SPEND TOO MUCH TIME WARMING UP, YOU'LL MISS THE RACE.
IF YOU DON'T WARM UP AT ALL, YOU MAY NOT FINISH THE RACE.

Grant Heidrich, runner

All successful and innovative design is created against a

clearly defined message and a focused set of objectives. If

you spend enough time analyzing, questioning, clarifying

and researching the message and objectives, the ideas flow

without effort. When contrivance and style intrude, they

clog the flow of ideas. The process of creating is

complicated; many factors influence its success or failure.

Clients can be pressured by internal concerns and politics,

designers can be driven by trend and technique, and

printers can be driven by technology. Managing the

process, controlling its influences, and keeping all team

players aware of the objectives will reduce creative erosion.

Getting to the Message

IF YOUR MIND IS EMPTY, IT IS ALWAYS READY FOR ANYTHING; IT IS OPEN TO EVERYTHING.
IN THE BEGINNER'S MIND THERE ARE MANY POSSIBILITIES;
IN THE EXPERT'S MIND THERE ARE FEW.
Shunryu Suzuki, author, Zen Mind, Beginner's Mind

IN CREATING, THE ONLY HARD THING'S TO BEGIN;
A GRASS-BLADE'S NO EASIER TO MAKE THAN AN OAK
James Russell Lowell, American poet, critic, editor, diplomat

Thinking With an Open Mind

There is nothing more frightful to a designer, writer, artist or philosopher than blank space—a white piece of paper. This fear is fueled by the fact that it is our job to fill that space. And not just to fill the space, but to fill the space with information that has meaning, influence and innovation. Intimidating, yes; impossible, no. The instant a mark, an image, a word appears on that blank page, the process of creativity begins. Apply any image to that piece of paper—a *hat*, for instance—and your mind begins to wander in directions influenced by that image. Add the word *time*, perhaps, and your brain starts putting messages together by combining the two elements. Stare at these two elements for a while and more ideas, images and messages begin to take form.

 The key to creating a truly original, focused and appropriate idea is to start at zero—a completely open mind with no preconceptions. The second you build walls (your can'ts, shoulds and oughts), insert parameters and run into obstacles, your range of possibilities becomes limited.

 The same holds true for your clients and their audiences. If they come to your ideas, your design, with an open mind, you'll realize success through innovation. This is why you need to understand your clients' concerns and your audiences' needs. Addressing these needs and concerns directly will disarm immediate objections and open minds; you'll have a blank piece of paper on which to present creative approaches. On the other hand, your insensitivity and lack of concern to the clients' issues will be immediately interpreted as a lack of interest. Granted, some of these issues will be irrelevant to the real problem, but you need to listen to them. If clients sense you're discounting issues important to them, they will lock out any possibility for creative solutions later on. It is your job, as the designer, to pry open the minds of the clients, and the audiences, and to fill them with possibilities they never imagined.

Controlling the Creative Process

I bet you thought that producing creative work was singularly dependent on your ability to think creatively. We should be so lucky. Designers who are successful at producing truly innovative work are masters at controlling the creative process. They work with clients in a way that ensures that the visions in their minds fall in line with the clients' objectives.

> PEOPLE ARE ALWAYS BLAMING THEIR CIRCUMSTANCES FOR WHAT THEY ARE.
> I DON'T BELIEVE IN CIRCUMSTANCES. THE PEOPLE WHO GET ON IN THIS WORLD
> ARE THE PEOPLE WHO GET UP AND LOOK FOR THE CIRCUMSTANCES THEY WANT,
> AND, IF THEY CAN'T FIND THEM, MAKE THEM.
> *George Bernard Shaw,* Mrs. Warren's Profession

Successful and innovative designers present their ideas in such a way that clients see and understand the vision, approve that vision, and provide an atmosphere for the designer to successfully implement that vision. To do this, you must know who your clients are, understand their needs, and groom your relationship so that your ideas and approach meet their expectations. The key in building this relationship is managing these expectations.

Knowing Who the Client Is

Conventional thinking defines the client as the person who pays the bills and knows nothing of creativity and how it gets done. Defining the client in this limited way is a disservice to the creative team. "Clienthood" goes way beyond this. Clients are human beings, not machines that write checks. And they are the decision makers. Good or bad, rational or irrational, clients decide, evaluate, judge and approve. Under this definition, the person you talk to daily about a project may not be the client. This person may only serve as a messenger for the person who makes the decisions and calls the shots.

The real client, the decision maker, may be your contact's superior, someone several steps up on the organizational ladder, or someone in another department or even another country. You need to know if your contact is not your client. (That doesn't mean your contact is any less a part of the process or of no concern to you.) More important, you need to find a way to get closer to the actual decision maker. The greater the distance from the decision maker you are—physically, emotionally or logistically—the more difficult your job will be and, ultimately, the less creative the approved solution will be.

clients are human beings too!

Trust and Risk Redefine the Client/Designer Relationship

The Progressive Corporation Annual Report

Mark Schwartz of Nesnadny & Schwartz describes the building of a great client interaction. "We started our design business with Progressive Corporation. They were our first client and, over the past twelve years, the relationship has become a model we try to emulate with our other clients. Our work with Progressive is based on two things: a mutual trust of each other's opinions, and risk. Risk is Progressive's business. They are used to taking risks, and we rise to that challenge. The creative process that results is the perfect interaction of smart design, insightful fine art and aggressive business.

"Progressive has a wonderful collection of contemporary art. So the annual report has always been visualized through the use of fine art. At first it was a strictly decorative application of the art. But in 1985 the reports took a turn for the better." Why? "We got smarter," said Schwartz. "We reached a point where we understood the client and the company. We realized that the fine art could reinforce the message."

This year the word *redefine* emerged as the driving force. Progressive Corporation is redefining its direction as an insurance company and a business. Everything about this annual report—every detail and decision—is driven by that message. The dictionary serves as a metaphor for the concept. Illustrations from the Merriam-Webster dictionary appear on the cover and throughout the narrative and financials. The typography and design characterize dictionary design down to the thumb tabs on the cover and text pages, and the definition hot-stamped onto the back cover. The fine art photography of Zeke Berman, through its diagrammatic balance of whimsy, illusion and invention, helps to redefine Progressive as a delicate and aggressive balance of commerce and industry.

How do Nesnadny & Schwartz work with the client to produce creative work every year? The design process begins with a phone conversation to discuss the message and focus of the annual report with the client.

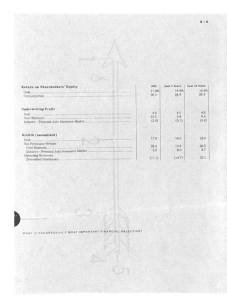

Schwartz and partner Joyce Nesnadny brainstorm together. Then they return to the client. "One of us usually takes the lead. We meet with Peter [Lewis, Progressive Corporation's CEO] to present and discuss a tight concept—tight in words, and not in layout. It's important for all of us to understand, verbally, what the message is and how it relates to the various players in the process."

Schwartz describes how the collaboration takes place. "Peter writes the book himself. We suggest a few directions in which he might take the copy and spin the message. We also meet with the curator of corporate art to choose an artist who could support the message for the year. And we begin to design. All of us are driven by the agreed-upon conceptual approach discussed in the presentation.

"We art direct the fine artist who has been chosen, but we work with that artist in a different way from most designers. We leave them alone. We give the artist all of the basics—the size of the book, the production constraints, the message and the fees. We don't see the art until it's done. (Well, we might get a preview, but that's it.) We work with reproductions of the artist's previous work so we can integrate the spirit of the art. At the end we drop in the finished illustrations or photographs."

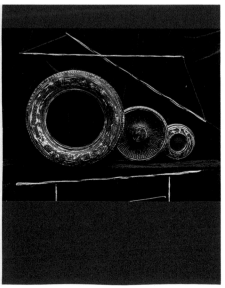

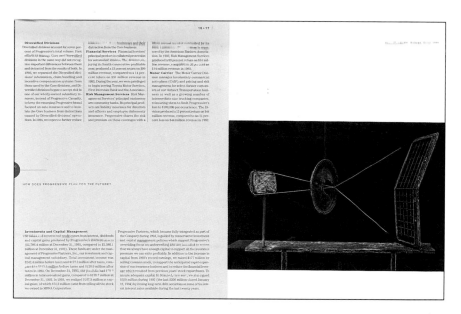

Diversified Divisions

Diversified divisions account for seven percent of Progressive's total volume. Past efforts to manage Core and Diversified divisions in the same way did not recognize important differences between them and detracted from the results of both. In 1993, we separated the Diversified divisions' information, claim handling and incentive compensation systems from those used by the Core division, and Diversified divisions began to accept risk in one of our wholly-owned subsidiary insurers, instead of Progressive Casualty, to keep the emerging Progressive brand focused on auto insurance and to insulate the Core business from distractions caused by Diversified divisions' operations. In 1994, we expect to further reduce

distractions from the Core business. **Financial Services** Financial Services' principal product is collateral protection for automobile owners. The division, enjoying its fourth consecutive profitable year, produced a 13 percent return on $90 million revenue, compared to a 14 percent return on $91 million revenue in 1992. During the year, we were privileged to begin serving Toyota Motor Services, First Interstate Bank and the Associates.

Risk Management Services Risk Management Services' principal customers are community banks. Its principal products are liability insurance for directors and officers and employee dishonesty insurance. Progressive shares the risk and premium on these coverages with a

multi-mutual insurer controlled by its trade customers. Its product is reinsured by the American Bankers Association. In 1993, Risk Management Services produced a 69 percent return on $16 million revenue, compared to 30 percent on $14 million revenue in 1992.

Motor Carrier The Motor Carrier Division manages involuntary commercial auto plans (CAIP) and pricing and risk management for select former customers of our defunct Transportation business as well as a growing number of intermediate size trucking companies, reinsuring them to limit Progressive's loss to $100,000 per occurrence. The Division produced a 13 percent return on $44 million revenue, compared to an 11 percent loss on $44 million revenue in 1992.

Investments and Capital Management
The bulk of revenue and profit comes from interest, dividends and capital gains produced by Progressive's investments ($2,786.4 million at December 31, 1993, compared to $2,386.1 million at December 31, 1992). These funds are under the management of Progressive Partners, Inc., our investment and capital management subsidiary. Total investment income was $242.4 million before taxes and $177.4 million after taxes, compared to $195.6 million before taxes and $139.6 million after taxes in 1992. On December 31, 1993, our plan also had $70.4 million in total unrealized gains, compared to $136.5 million at December 31, 1992. In 1993, we realized $107.3 million in capital gains, of which $74.3 million came from selling all the stock we owned in MBNA Corporation.

Progressive Partners, which became fully integrated as part of the Company during 1993, is guided by conservative investment and capital management policies which support Progressive's overriding focus on underwriting and are intended to ensure that we always have enough capital to support all the insurance premium we can write profitably. In addition to the increase in capital from 1993's record earnings, we raised $177 million by selling common stock, to support the anticipated rapid expansion of our insurance business and to reduce the financial leverage which resulted from previous years' stock repurchases. To assure adequate capital to maintain our new rating, we also raised $350 million during 1993 (the last $200 million closed January 12, 1994) by issuing long-term debt securities at some of the lowest interest rates available during the last twenty years.

HOW DOES PROGRESSIVE PLAN FOR THE FUTURE?

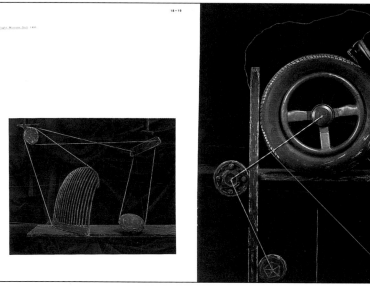

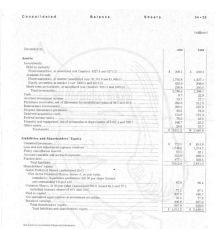

Ask about the approval process at the beginning of all projects. Identify the individuals who will approve the work and ask that they be involved in objective-setting discussions from the beginning. Each individual who evaluates and judges design brings to the process his own prejudices, tastes and experiences. (Multiply the complexity of these tastes times the number of decision makers, and you will discover why design judged by committee is so often passive and unimaginative.) Ongoing involvement gives participants ownership of the information discussed and the solutions developed. More important, the unique concerns of all participants are voiced at the beginning of the project, not halfway into it.

THE GREATER THE DISTANCE FROM THE DECISION MAKER YOU ARE—PHYSICALLY, EMOTIONALLY OR LOGISTICALLY—THE MORE DIFFICULT YOUR JOB WILL BE AND, ULTIMATELY, THE LESS CREATIVE THE APPROVED SOLUTION WILL BE.

You see, innovative design requires a process. This process involves discussions and interaction—verbal and nonverbal, concrete and intuitive communication—between "creator" and "createe." Creative successes are achieved by presenting innovative and unique design to your client, on rational grounds, through ongoing project communications. But insert an individual, a decision maker, who is unaware of discussions to date, especially at a critical approval point, and suddenly a creative solution is misunderstood. It is evaluated in a vacuum outside of the context in which the solution was created. It is judged against criteria not previously discussed. Even more frustrating, these previously uninvolved decision makers can add objectives or parameters after information has been processed and creative work has been developed.

Knowing these pitfalls from the start helps the designer to control the creative process. You can develop innovative solutions to a fixed set of parameters or constraints. It is difficult to do so, however, when these parameters change midstream. Such changes can reduce a brilliant solution to a mediocre thought.

EINSTEIN, AMONG OTHERS, BELIEVED THAT THE REALLY IMPORTANT BREAKTHROUGHS IN SCIENCE COME AS A RESULT OF REFORMULATING OLD PROBLEMS OR DISCOVERING NEW ONES, RATHER THAN BY JUST SOLVING EXISTING PROBLEMS.
Mihaly Csikszentmihalyi, author and educator

Your role as a designer will be more respected and perceived on a higher professional level if you spend time clarifying the creative developmental process and project team roles. This is

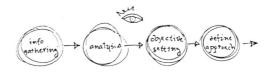

particularly important in large projects such as annual reports, or long-term projects that include multiple pieces. The most effective way of communicating the creative development process is through the project proposal. When you are asked to provide an estimate of fees and expenses for a project, provide a brief summary of who you understand to be a part of the project team, in your organization and in the client's organization. In addition, briefly describe:

- *The phases in the development of the project.* Explain each phase, such as concept phase, design application phase, production phase, print phase and so on. The description should be brief and in terms that the client will understand. Explain why this phase is important to the client—for example, "During the information-gathering phase we gather all background and other relevant information that defines the problem and supports the need for a solution. This information includes internal communications, competitive information, market research, and interviews with marketing, sales and technical support staff. The background information is analyzed and dissected to provide a concrete starting point for design concept."

- *Who is involved in each phase, and how.* Role definition includes explaining how the client, the design firm, the writer and the vendors are involved in the process—for example, "This phase will include two information-gathering meetings with the designer, the writer and the client to discuss all background information. We recommend that the department director also attend these meetings to facilitate a comprehensive discussion of all issues surrounding this project."

- *What to expect at the conclusion of each phase.* This is the last sentence of each phase description—for example, "At the conclusion of this phase we will submit an outline of issues surrounding this project as well as a summary of communications objectives for approval. This list of objectives will serve as a guide against which we will evaluate all proposed solutions. It is imperative that all persons with decision-making authority review the list of objectives and approve it prior to beginning the next phase."

THE ENTIRE CREATIVE PROCESS IS BASED ON TRUST. TRUST BETWEEN WRITER,
DESIGNER AND CLIENT. IT'S LIKE WHEN YOUR DAD TOOK YOU TO THE POOL
FOR THE FIRST TIME AS A KID AND HE SAYS JUMP, I'LL CATCH YOU.
Todd Lief, writer

brainstorm → evaluate → refine → approve → implement → result

Preparing the Client for Creativity

You can make two basic mistakes in discussing a project with a client.

1. Giving too much credence to what the client says.
2. Giving too little credence to what the client says.

Clients (as all of us can be at times) are guided by immediate concerns and problems, the ones sitting in front of their noses. Most often they are forced to solve these problems quickly, painlessly and inexpensively. By the time they recognize the need for a designer, they believe much of the problem solving already has been completed. Before the designer even enters the scene, the project too often has been outlined and defined against unreal expectations and illogical objectives that were developed through an inappropriate process.

When talking to the client, you must separate credible information from conjecture, guesswork and illogical thinking. You will discover valuable thinking in what the client says. You will also discover an abundance of panic-driven decisions. Understand the difference between the two. You are an objective participant in the problem-solving process. Help the client be objective, too. Show him what the true problem is—and appropriate ways to solve it.

Often clients will drift into "problem-solving mode" during your conversation. That means they try to solve the problem by making decisions on format, color and paper before you or they even know what the problem is. Clients often try to play "designer," attempting to direct the visual outcome at all points throughout the creative process. This happens because:

- The client is aware of no other approach. These are tangible ways of dealing with abstract concepts, issues and problems.
- Color and aesthetics are "fun" compared to managing the issues.
- The client has no understanding of what design is and how it can assist in strategic thinking.
- The client handles the problem in the same manner as she has handled other problems in the past.

This situation is easily managed if dealt with immediately. Always acknowledge the client's input, but don't embrace it on the spot. Instead, redirect the conversation back to fact finding. Suggest you will consider her opinion when the time comes for those decisions. Or ask how her solution fulfills the specific needs being discussed. (Always ask questions related to this input and let the client come to

input

organize

her own understanding of the suggestion's appropriateness. Never criticize your client.) The better a client understands that the solution is driven by the objectives, parameters and facts surrounding the problem, the more likely she will see the logic in what you discuss and what you ultimately present.

TO TAKE THE LEAPS? A PROVOCATIVE QUESTION IS THE ONLY WAY THAT I'VE FOUND.

James F. Bandrowski, President, Strategic Action Associates

Client as Creativity Gatekeeper

Opening a client's mind is particularly important because he serves as the gatekeeper for creative communication. If the client does not believe in your ideas, those ideas won't get produced. This is not to say that design is dictated by the client's taste, philosophy and approach, however. You can effectively manage the creative process through diplomacy, negotiation and influential communication, starting with the initial meeting and continuing through the finished product.

YOU CAN EFFECTIVELY MANAGE THE CREATIVE PROCESS THROUGH DIPLOMACY,
NEGOTIATION AND INFLUENTIAL COMMUNICATION, STARTING WITH THE INITIAL
MEETING AND CONTINUING THROUGH THE DELIVERY OF THE FINAL PRODUCT.

The first *touchpoint*—the first opportunity you have to interact one-on-one with the client, and your first opportunity to influence the process—is the project initiation interview with the client. When a client perceives he has a problem with his company's image or communications, he approaches a designer. But his perception of the problem is colored by his environment and the daily issues churning in his life. That's where you come in. A fresh, objective and open mind—your mind—brings a different perspective of the problem into the discussion. If you effectively manage the interview process, you can help the client achieve a new, more objective, perception of the problem. Begin the interview with questions such as these:

1. What are you trying to communicate, and why?
2. Who needs this information, and why?
3. What does this audience already know? What does it need to know?
4. What single, unique, focused message should the audience walk away with after reading or seeing this piece?
5. What have you done to communicate this information before?
6. How do you expect your audience to respond to this communication? How will you in turn respond to your audience's response?

Challenging Preconceptions

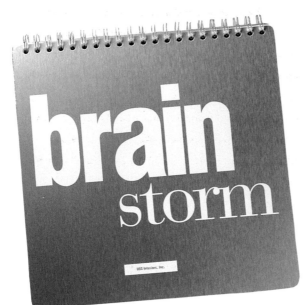

Brainstorm

USG Interiors, Inc. is a manufacturer of ceiling, wall and floor systems for installation in interior spaces. The company had developed a new product development service for architects and interior designers. The service would let them help conceive and then have manufactured large quantities of custom-designed interior products for use in multiple commercial spaces. This process is quite different from the standard one of designing to and specifying from a standard inventory of catalogued products.

The new project development service required the involvement of product developers in the space design and planning process, something quite out of the ordinary for architects and interior designers to accept. Since **USG Interiors** had been known for its quality and technical expertise—not for its creativity—the promotion for the new service had to redefine the company's image to this key market.

USG Interiors thought it knew this market. The client asked **Mark Oldach Design** to develop a packaging device, possibly a pocket folder, to hold a variety of

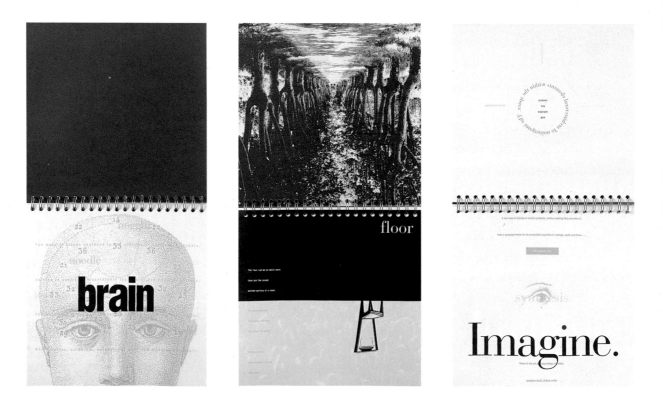

preexisting product sheets. This package would explain the new service, while the product sheets would present the array of products and manufacturing possibilities available from the company. The client hoped that architects and interior designers could imagine the possibilities based on current products. We didn't think the market would make this leap.

So there were two issues. USG Interiors needed to present itself as a creative (as well as a technical) company and to introduce a service that represented limitless options, not just existing ones. We discussed these issues with the client and challenged the initial approach by showing how it wouldn't achieve the objectives. We then agreed on a focused message based on the objectives. The piece must:

- Detail a design process used by architects and interior designers that involves product development people from **USG Interiors.**
- Let the audience imagine the possibilities by using no preexisting product or interior designs.
- Present the company as a creative force.
- Detail the service in a way that the audience would read and understand.

We brainstormed the conceptual approach in a three-hour session with the writer the client had assigned to the project. It took three or four more meetings to flesh out the concept, writing and approach. The fifteen-page manuscript of quotes, thought bites, prose and sell copy translated into a seventy-four page black-and-red book printed on translucent paper. The piece begins by challenging conventional thinking about creativity and interior space. The reader is then asked to imagine a process that synthesizes the creative and the technical thinking (right brain and left brain thinking) into a single product development process. Finally the piece outlines the process. The translucent paper and the interaction of images and words tease and entice the reader into consuming the entire book, page by page.

Every aspect of this piece was conceived and produced to stimulate creative thinking. The process was illustrated by showing how it could be used to design an umbrella, which was used as a symbol for a room. An umbrella can represent the idea of a space with a ceiling, walls and floors, although it really doesn't have them. We used the umbrella instead of a literal room to avoid confining the audience's expectations to what they could see before them. The umbrella concept was metaphorical and therefore kept all options open.

The metal cover of the book was custom manufactured using the client's own product materials, an example of **"See, we really can do this."** A prototype was market tested before it was produced to hone the content to essential information. The presentation gets the audience to read the book cover to cover. They return to it over and over to capture the magic it conveys. The client embraced this unconventional approach with tremendous spirit as it began planning the product launch activities. Their enthusiasm inspired much of the substance of the follow-up campaign, including the giving away of umbrellas emblazoned with the Brainstorm logo at the launch party.

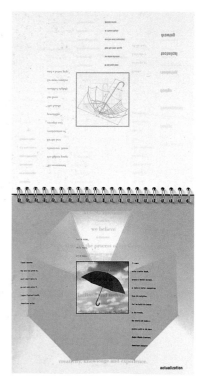

7. Will the audience receive the same information in any other form or media from your organization as part of a campaign? Or as part of another organization's communication?

8. Does the audience want this information? Do they not want it? Do they care?

The more important questions, those unique to this project, evolve out of the discussion. These questions lead to answers that translate into truly creative and innovative solutions. Often the very answer to the design problem comes directly from the client.

You must be the catalyst for this discussion and exploration process. To effectively manage it, remember to:

- *Listen.* Let the client do all the talking. If you find yourself doing most of the talking, stop. Ask a question and listen to the answer.

- *Listen for the client's vocabulary, insight and knowledge.* These will guide you to the unique solution to this unique problem.

- *Ask questions using the client's vocabulary.* This will prompt the client to talk more. Don't worry if you misuse or misunderstand a term. Clients will correct your misuse of their jargon, thereby giving you a greater understanding of the language. As clients begin to hear themselves in what you say, they become more conscious of points they overlooked or took for granted.

- *If you don't understand, ask for clarification.* No question is inappropriate. You can't have too much information, and no information is bad information. If nothing else, information conveyed in this meeting gives you more insight into what and how the client thinks.

- *Write down key points, but don't let note-taking get in the way of listening.* You can always clarify details later, but this is the only opportunity for you to get a handle on the "big picture."

- *Challenge the client's preconceptions.* The initial interview is the touchpoint when a client is most open to different ways of thinking. Too many designers roll over and play dead to a client's every command, fearing they will lose the job if they question or disagree. This blind obedience is not what any good client is asking of you. It is true that in some cases the client's preconceptions about the problem or the project will have a sound rationale, but you need to hear her reasoning to accept it. Many times a client's preconceptions are unfounded, and often she can—and even wants to be—convinced to accept your sound, professional suggestions.

- *Do not try to solve the problem on the spot.* Offer no solutions. Just open doors.

listen!

ask for clarification

- *Encourage all participants in the design evaluation process to be present for the interview.* A lot of processing and analysis of the problem and information occur during a client interview. If all of the individuals who will evaluate your solutions are in the initial meeting, you will have informed evaluators at the final presentation.

- *Decompress immediately following the interview.* Do what I call an immediate "mind dump," creating a freely flowing record of what's in your brain. Write down every detail, thought, concept and fact that comes out of your head. Don't edit while you're writing. Just record. The document you create during this session will be one of the most valuable resources you will have in thinking creatively and appropriately. Because this is your first and most objective exposure to this information, your mind can bring extra intuition and fresh analysis to it. The insight that results often will lead to the seed that grows into the best ideas. Refer to this document during brainstorming.

THE ONLY DUMB QUESTION IS THE QUESTION THAT YOU DON'T ASK.

Paul MacCready, inventor

Managing Expectations

You now know the members of the client's team and how they are involved in the creative development process. So, how do you work with them to facilitate a creative solution? The worst thing you could do would be to take the information gathered at the initial interview, return to the office, close yourself off for three weeks in a white room with Tizio lamps, and emerge with a finished presentation. You set yourself up for failure if you totally remove the client from the creative process.

Creative solutions are, by definition, solutions that are untried. They involve risk and require clients to make decisions that often do not meet with immediate, universal acceptance. Creative solutions frequently represent a journey through uncharted (and possibly rough) territory for clients. The rewards can be great, but the client does not know this. You must prepare him for creative, potentially risky solutions.

OFTEN THE VERY ANSWER TO THE DESIGN PROBLEM COMES
DIRECTLY FROM THE CLIENT.

Present risk, or the possibility of it, to the client early in the process. This will give him enough time to prepare himself and those around him for creative solutions. Any client can turn into an immovable stone wall if you haven't prepared him for risky and innovative solutions. Without this preparation,

prepare
the client
for risk!

clients begin to imagine awful, risky approaches. This can work for or against you. Sometimes what clients imagine you mean by "innovative" is much worse than what you ultimately show them (making your presentation appear appropriately conservative). On the other hand, this same imagination might squelch your creativity before you even get to the presentation. Which is why it is important to discuss "risk" and "innovation" early in the relationship.

CREATIVE SOLUTIONS ARE, BY DEFINITION, SOLUTIONS THAT ARE UNTRIED. THEY INVOLVE RISK AND REQUIRE CLIENTS TO MAKE DECISIONS THAT OFTEN DO NOT MEET WITH IMMEDIATE, UNIVERSAL ACCEPTANCE.

Test the limits of a client's willingness to take risks during the initial interview. Is she willing to support a unique solution before her colleagues? How much do organizational politics dictate her decision making? Often a client wants to take risks but fears that her boss(es) or the intended audience won't be receptive. Test the limits here, too. Can you do some formal or informal research to support a creative approach with the client? Can you show the client an example where others have spoken to the same audience in a unique way?

I SUBMIT TO YOU, CREATIVITY'S NOT TALKING;
IT'S ALL ABOUT THE ABILITY TO LISTEN.
Marc Steuer, Syntex

Remember, if a client calls you, asks for your expertise and wants new solutions, she is seeking guidance through the whole creative process. If you effectively manage that process from the beginning, she will respect your insight, questions and options at critical decision-making points.

During the creative development process you should:

- *Talk to the client, on the phone or in person.* Let him know what you think, what progress you've made, and what problems you've encountered.
- *Involve the client in your problem solving and analytical thinking.* Test your thinking and get reactions.
- *Hint at some approaches you might take.*
- *Continue to prepare the client for unexpected solutions.* Advise that your solution might require new ways of thinking about the problem.

Beyond the Client Interview

Decompressing After the Interview

During the client interview you must listen to the client rather than lose focus by writing everything down. You can take some minor notes to tickle your brain, reminding you of the conversation that took place. But you still need to record the substance of the conversation before you lose too much information from your short-term memory. Immediately following the interview, sit down and recall the conversation onto paper. Empty your brain of all the information you've collected. This is a good information-processing technique that will help you analyze and evaluate the conversation. Some people write out the information while thumbnailing visuals that occur to them in process. Some sit at a computer and expand on the information as they review their notes. It doesn't matter how you do this exercise, it only matters that you do it. You'll be amazed at how much information you recall from the conversation, triggered only by your sketchy notes. Don't put off doing it. If you don't write the information down immediately, it will disappear.

tickle
the
brain.

> CREATIVITY REQUIRES A SANDBOX LARGER THAN INK ON PAPER.
>
> *Clement Mok, Clement Mok designs, Inc.*

> IDEAS AND CREATIVITY COME FROM WHAT YOU KNOW. A DESIGNER'S ROLE IS TO BE
> AWARE OF EVERYTHING. YOU CAN PULL OUT OF YOUR HEAD ONLY WHAT IS IN THERE.
>
> *Kris Clemons, Gerhardt & Clemons, Inc.*

Looking Beyond the Client for Information

Information gathering goes beyond interviewing your client. The client is your most important information resource. However, you can glean significant insight and inspiration from other sources.

In discussions with your client, you will touch on issues such as company or product positioning, competition in the marketplace and audience profile. Client input in each of these areas may lead you to other sources of information that could inspire a unique approach.

decompress write the info down immediately.

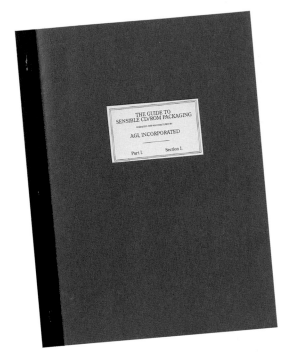

CD-ROM Packaging Marketing Program

AGI, Incorporated, a packaging firm, wanted a capabilities piece to market its new CD-ROM packaging program. Since the CD-ROM industry is taking off, it was important to establish the client as a leader in packaging for this media. They felt they would be competitive with something reflecting the technical character of the computer industry—something slick, colorful and high tech.

"In looking at the company and hearing them talk about themselves, we realized they aren't a high-tech, computer-driven company," explained Dana Arnett of VSA Partners. "They are a manufacturer driven by sensible thinking and focused on issues of quality, deadline, production and structure." Enter Boxhead Man. "We separated the company from the high-tech image of the competition by using low-tech and high-touch sensibilities. We embraced the concept, 'We are sensible about packaging,' and used Boxhead Man to communicate that image. It's a concept that is visually driven, like a comic book. We storyboarded the message of discovery and satisfaction. You know, Boxhead Man finds what he needs, devours it, and he's happy.

"We came to the presentation armed with

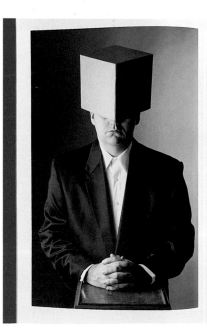

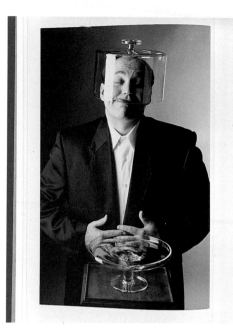

THE GUIDE TO SENSIBLE CD/ROM PACKAGING

THE DIGIPAK® OFFERS THE SATISFACTION OF MAKING THE RIGHT PACKAGING DECISION DOWN TO THE LAST BYTE.

The spirit of innovation and commitment to quality that spawned the DIGIPAK® are the driving forces behind AGI. With our emphasis on applying our expertise to the unique requirements of our clients, AGI, directly and through our licensees around the world, has produced more than 88 million DIGIPAK's since 1987. And along the way, we have produced award-winning packages in industries as demanding as cosmetics and entertainment—not to mention garnering awards for helping clients develop environmentally friendly packaging.

Our dedication to creating the most sensible CD/ROM packaging doesn't end with the DIGIPAK® itself. To meet the wide-ranging needs of our clients, we provide the Retail Ready Packaging Service—one-stop shopping that helps you develop and distribute your unique CD/ROM product in a package that works for you.

With the Retail Ready Packaging Service we provide:

DESIGN

AGI works with your marketing and purchasing personnel to develop a complete package that complements your new product.

MANUFACTURING

Our team works with your organization to bring together all facets of the printing and converting of the packaging components to insure that the products are of the highest quality.

ASSEMBLY

AGI planners work closely with reputable and versatile suppliers to collate all components in time to meet your retail date.

DISTRIBUTION

AGI's central location in suburban Chicago allows us to ship your finished product to any destination with the greatest economy.

WAREHOUSING

AGI's 250,000 square-foot manufacturing facility provides ample space to warehouse your finished goods. The efficiencies of volume purchases and just-in-time shipments help you control costs.

strategy and information to counter their expectations. But we didn't need it. They loved the approach. They embraced Boxhead Man with the affection of a newfound mascot. Everyone—the writer, the photographer and the client—had ideas on what Boxhead Man should be doing. We dropped the character into the environment of a stripped-down, clumsy, raw 1950s technical manual. The awkward typography, ugly cream paper, and bad gloss varnish visually supported the concept. We also bought ourselves more creative time with this approach, by not having to deal with prepress and on-press color issues. And suddenly the client became focused on what and how we think, which translated into a stronger relationship.

THE GUIDE TO SENSIBLE CD/ROM PACKAGING

THE ONLY WAY OUT OF THE WOODS IS TO BEGIN THINKING CLEARLY ABOUT EFFECTIVE, EFFICIENT PACKAGING.

THE FIRST STEP TOWARDS FINDING THE RIGHT PACKAGE FOR A CD/ROM PRODUCT IS TO CONSIDER PACKAGING AN INTEGRAL PART OF THE PRODUCT'S DEVELOPMENT AND DISTRIBUTION, AND NOT A NECESSARY EVIL. TAKE WHAT YOU ALREADY KNOW ABOUT YOUR MARKET—ITS NEEDS, ITS PREFERENCES, ITS EXISTING PARTICIPANTS—AND TRANSLATE THIS INSIGHT INTO THE PACKAGING SYSTEM. AFTER ALL, THE PACKAGING WILL MAKE THE FIRST IMPRESSION ON YOUR MARKET, AND YOU WANT IT TO BE A POWERFUL ONE. IT IS THE BEST OPPORTUNITY YOU HAVE TO PERSUADE POTENTIAL BUYERS THAT YOURS SHOULD BE THEIR PRODUCT OF CHOICE. AND, WHENEVER POSSIBLE, START THINKING ABOUT PACKAGING SOONER RATHER THAN LATER. AFTERTHOUGHTS ARE OFTEN SHORTSIGHTED, AND MAY LACK THE STAYING POWER OF A PROGRAM THAT HAS THE TIME TO EVOLVE AS THE PRODUCT ITSELF GOES THROUGH ITS NATURAL DEVELOPMENT CYCLE.

SINCE YOUR PRODUCT IS UNIQUE, IT STANDS TO REASON THAT THE DEMANDS IT MAKES ON PACKAGING ARE UNIQUE, TOO. THIS POINTS TO ANOTHER ESSENTIAL TRUTH ABOUT SENSIBLE PACKAGING: IN ORDER TO ACCOMMODATE YOUR PRODUCT'S DISTINCTIVE NEEDS, BOTH TODAY AND IN THE FUTURE, THE PACKAGING MUST BE FLEXIBLE—BOTH EXTERNALLY AS WELL AS IN TERMS OF THE INTERIOR SPACE IT PROVIDES FOR DISC/DOCUMENTATION STORAGE. AN OFF-THE-SHELF SOLUTION WILL ALWAYS APPEAR TO BE JUST WHAT IT IS: A PACKAGE THAT HAS BEEN DESIGNED FOR NO ONE IN PARTICULAR.

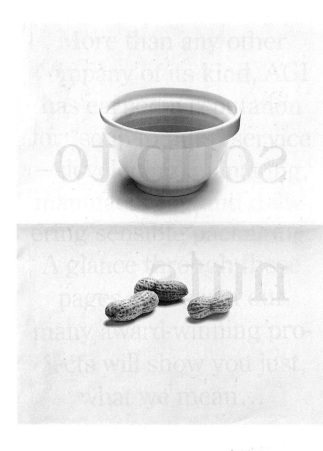

"The brochure was followed up with two newspapers. They were really low-tech. I think we printed something like 40,000 copies for about $1,500. The Soup to Nuts brochure is a portfolio of products and the Getting Sensible brochure is more of a technical capabilities piece. I think our brains were able to tap into their industry easily because it parallels our industry so much."

Arnett explains how he uses his creative thinking. "I work from a sketchbook. I have to sketch. I don't think a lot of designers use a sketchbook anymore. It's a shame. And I can't design with decoration. I work with words and positioning. I have sort of a boilerplate style, ironically. It's long on communication and short on style. It's blunt; it's bare bones. One of the designers in my firm says that I work with a ball and chain around my ankle, and the word `logical' appears in big letters on the ball.

"We collaborate with the client a lot. Bob Vogele [the V in VSA Partners] told me early in my tenure here that people will support what they help to create. Clients have something to say, and they want you to help them say it. But you better have a good idea with a solid strategy when you let the client into the creative process. Otherwise they'll mow you over.

"We always write a design brief that serves as a verbal road map on how we arrive at a solution. That design brief is presented prior to any visual presentation. The client is rarely surprised by the time they see the layout. The solutions may be risky—for you and for them—but if you stay away from subjectivity, the solution will work."

soup to nuts.

More than any other company of its kind, AGI has earned a reputation for "soup to nuts" service — developing, managing, manufacturing and delivering sensible packaging. A glance through these pages at a few of our many award-winning projects will show you just what we mean…

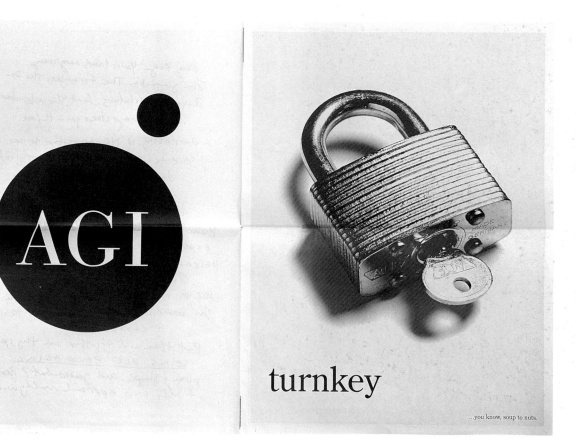

AGI

turnkey

…you know, soup to nuts.

Competition. The client's competition is a key source of information for determining how your client stands apart from the crowd. Pick up the phone and call competitive companies to inquire about their products or services. Ask them why they are better than your client. Request and review their product literature, stationery, communications program. Talk to a salesperson. Talk to a receptionist. If you pose as a potential customer or concerned party, most sales and marketing personnel will be forthcoming. This information will build on what you already have learned from your client.

> I AM INSPIRED BY GOING TO FLEA MARKETS AND CRAFT FAIRS. WE MIGHT TURN OUR NOSE
> UP AT THE TOILET PAPER HOLDERS, BUT THERE'S SOMETHING EXCITING AND PRECIOUS
> ABOUT THE SPIRIT COMING FROM PEOPLE WHO MAKE THESE THINGS WITH THEIR HANDS.
> *Todd Lief, writer*

Parallel industries. Inspiration can be found anywhere—art, science, mathematics, history, architecture, quantum physics. When working to communicate something unique for your client, look to other fields, locations, subjects, time periods and industries to draw parallels to the problem at hand.

It is interesting to examine how other companies communicate. You've looked at companies that compete with your client. Now look to other industries and examine how they communicate. What makes them unique? Why does their unique approach to communications work in an otherwise conservative marketplace? Use good and bad examples of effective and creative communications in other industries to guide you in developing a unique solution for your client.

Historic precedents. As the saying goes, "History repeats itself." Everything is cyclical. What goes around, comes around. Look to the past to provide you with insight into innovation in the present. A student of design history sees cultural and sociological factors influencing style and design. A close examination of those factors, those influences, might give you unique insight into your client's problem. It is important, however, not to stop at examining the style. Examine the environment, influences and causes of the style.

Audience profile and motivation. Too often the designer and client get caught up in the problem without understanding the audience. Designers should be an advocate for the readers. Unfortunately, we often find ourselves at odds with the readers. Designers continually put style before legibility and understanding. This is okay if style is the only thing that motivates your readers (which sometimes is

bird

idea

nest.

look in
unpredictable
places
for ideas.

PREPARING FOR IDEAS

cup | ♪ | 25

the case). But most often you want the readers to read. How readable should the piece be? Look to the profile of the readers. You can gain enormous insight and inspiration simply by getting inside the audience's brain. Get to know the readers. Understand what makes them tick. Act like the readers for a moment. Talk like them. Walk like them. If you, as the surrogate for the reader, come to the message with poor eyesight, you'll want the type bigger and less distorted. If you come to the message confused, you'll want the information visually organized.

Defining the Boundaries for Creativity

There are no limits to creativity, given established, unchanging objectives and parameters. A motivated designer can work within any fixed set of rules. The trick is to make sure those rules do not change after project development has begun. The parameters can be set by client, printer, computer, audience and even designer. Define the limits early. Write them down. Share them. Talk about them. Connect them to the objectives. Document them in the design criteria. And translate them into opportunities that ultimately frame the innovative solution.

Don't look at boundaries and parameters as limitations to your creativity. They actually narrow options to a manageable level. You can easily be overwhelmed approaching a situation with too many creative options available. Let boundaries serve as opportunities, but make sure they are fixed from the beginning.

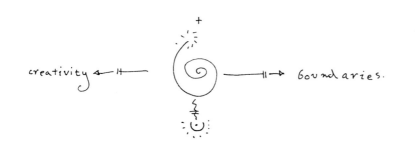

<div style="writing-mode: vertical">

Analysis as a Creative Tool

</div>

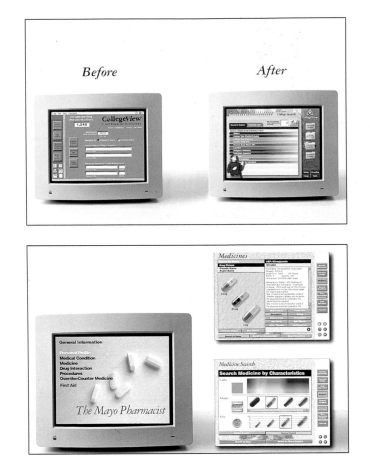

Before After

Medicines

Medicine Search
Search Medicine by Characteristics

General Information

Personal Profile
Medical Condition
Medicine
Drug Interaction
Procedures
Over-the-Counter Medicine
First Aid

The Mayo Pharmacist

Mayo Clinic Pharmacist CD-ROM

Interactive Ventures asked Clement Mok designs to design an interactive information system for pharmacists to use in accessing significant medical and pharmaceutical information quickly and easily. The interface between computer and user required creating easy access to a large database of information with a variety of entry points. The design solution presents the information as accessible, organized, user-friendly and understandable. If you just look at it, it doesn't appear to be a highly creative solution. But to the pharmacists who use it, it's wonderful.

Mok and his staff spent nearly three months immersing themselves in the information, analyzing all of it from the point of view of the pharmacists who would use it. The information itself is textbook in nature. The creative part is in the design of the interface between the user and the information. The secret to the success of this design is the understanding of who the audience is and what information they need. When the team at Clement Mok designs put itself in the shoes of the audience—pharmacists—they realized how important it is to access information quickly.

The design team used a key creative tool in imagining the interface, a brainstorming technique referred to as "What if … " This creative tool is a form of role-playing with one foot in reality and the other in fantasy. Sitting in a room with the information in front of them, members of the group asked each other "What if … " questions. "What if we could identify drugs by color? Or shape? Or size? What if we could enter in a series of symptoms for an illness and have the database tell us the appropriate medicine or, better yet, tell us to see a physician immediately?"

This interface design and its implementation with great attention to detail is a study in creativity on an analytical and strategic level. The style enhances the audience's understanding. The creativity enables the user to access the information easily and quickly.

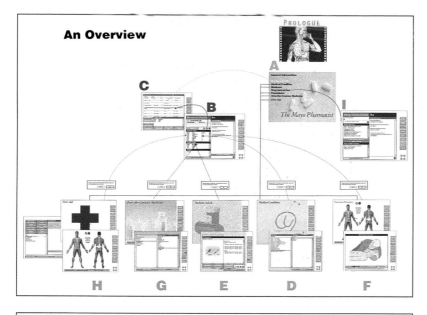

An Overview

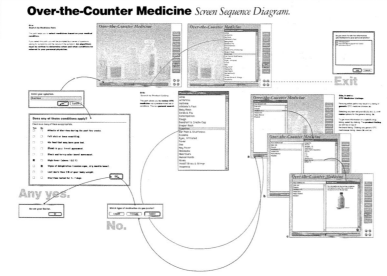

Over-the-Counter Medicine *Screen Sequence Diagram.*

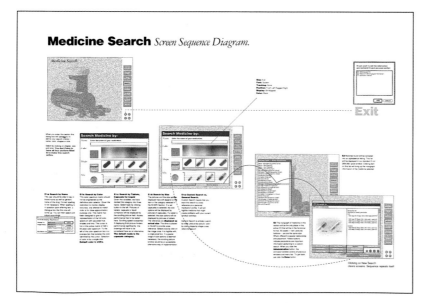

Medicine Search *Screen Sequence Diagram.*

Processing the Information

You've talked to the client. You've researched the competition, the audience, the environment. What do you do with all of this information? Start to design? Stare at your notes while scratching your head? Go on vacation? Run in the opposite direction?

Actually, the last two options are not as far off base as you might think. The most important thing you can do at this point is fill your brain with all of the information. Pack it in there, nice and tight. And then get away from the project for a while. Let the subconscious do the work for once. Sleep on it.

> THE MERE ACT OF OBSERVING SOMETHING CHANGES THE NATURE
> OF THE THING OBSERVED.
>
> *Werner K. Heisenberg, "Heisenberg Uncertainty Principle"*

> WHY IS IT I GET MY BEST IDEAS IN THE MORNING WHILE I'M SHAVING?
>
> *Albert Einstein, physicist*

But first, the information must by funneled into your head in an organized form that helps you to analyze it and process it *while you do other things.*

- *Review your notes and research.* Begin to sort out pertinent information from extraneous and irrelevant information.

- *Reorganize the information.* Reorder it in a way that is different from the way the client presented it. This will give you a different perspective on the same information. Develop a logical outline and hierarchy for the information. This will help your mind retain more information while it is processing.

- *Restate the information in a variety of forms.* This is another way to look at the same information from a different point of view. It also helps you to evaluate the information and refine the objectives of the project.

- *Readdress the objective of the project.* Listen to what the client actually asks you to communicate relative to what the audience needs to know. Often these two are at odds with each other. This is the easiest point in the process where you can challenge the stated objectives of the project. Be diplomatic; challenge does not mean argue or disagree. It means, "Ask questions to confirm an assumption—yours or the client's. Usually this is

fill your brain with all of the information

and then sit a spell.

done through questioning. Instead of saying, "I don't think you're talking to the right audience," begin a series of questions to challenge the client's thinking. "Who is your current target audience?" "How did you identify this audience?" "What has the reaction from this audience been so far?" "Have you considered other audiences?" And so on. Challenge the client's assumptions and understand where those assumptions came from. Enough questions will confirm or contradict the assumptions.

- *Reword the objective of the project as design criteria.* Change the language of the objective into a visual language that will help define the design issues. For instance, a client wants to produce a publication that will not be lost in the mass of corporate communications and interoffice mail distributed internally. This translates into an objective: "The communication must be unique and memorable. Every word must be read by each employee. It does not need to be saved, but it must be understood." This objective translates into design criteria such as, "The communication should be other than 8½" x 11". The text should be broken into digestible blocks of copy for easy skimming. The piece should be brief and direct. It should be highly visual."

When you have immersed yourself in the information to the point of saturation, stop. File the notes. Close the books. Put away your Rolodex cards and relax. Take a break, take a hike, or take up another project. This is where you let your brain show its stuff. Give yourself the luxury of time to let the information marinate in your brain. The *off time*, the time that you relegate the project to your subconscious, will give you the chance to spice the mix of information with outside influences. At this point, everything you do, see, touch, feel, taste, think, experience and hear will influence the way you see the information when you return to it.

GIVE YOURSELF THE LUXURY OF TIME TO LET THE INFORMATION MARINATE IN
YOUR BRAIN.

How long should this process go on? As long as your schedule permits. The more spice you add to the basic information, the more spin you put on the solutions that emerge. Minimally, this process might take a few hours. Optimally, it should take a few days. It could even take a few weeks, if you have that much time. When you can let the information stew for more than a few days, review the information every couple of days. This will bring the information back to the surface as it begins to fade behind more immediate concerns.

Understanding and Clarifying the Message

Creative approaches evolve from a clear understanding of what needs to be communicated. Often a client presents you with a project or problem that has multiple audiences, varied messages and unfocused objectives. This leads to confusing and unfocused design and the need for excessive text and complicated images. (This is, of course, always the designer's fault when it doesn't work rather than the client's fault for being unfocused.) Often the message contains too much information for the audience to even comprehend.

THE OBSCURE WE SEE EVENTUALLY, THE COMPLETELY APPARENT TAKES LONGER.

Edward R. Murrow, broadcaster

IF YOU SEE IN ANY GIVEN SITUATION ONLY WHAT EVERYBODY ELSE CAN SEE,

YOU CAN BE SAID TO BE SO MUCH REPRESENTATIVE OF YOUR CULTURE

THAT YOU ARE A VICTIM OF IT.

S. I. Hayakawa, semanticist and former senator

A single communication piece can't be all things to all people. The more specific the message and the more focused the audience, the more effective the results. A clear message is characterized by several factors:

- *Focused objectives.* You and your client must agree on what the piece should accomplish. Your objective should be stated simply and must be specific to the situation. For instance, if you design an identity program for a writer, the objective would be to clearly communicate her name and location on all materials she distributes. The audience must recognize the writer's materials on viewing any and all communications. If that writer has expertise in technical writing, you might focus the objectives by noting that the communications must convey the technical character and personality of the writer's work. The key is to be as specific as possible.
- *A single, clearly defined audience.* It is difficult to persuade both a sixteen-year-old and his seventy-five-year-old grandparent in the same communication. Each uses a different language, lives within a different culture, and brings a different set of experiences to the situation.
- *Defined expectations.* You must know how the client will evaluate the success of the communication. It is not enough for her to simply say she likes the piece. She instead should indicate what she expects this piece to accomplish and how she will measure this.

- *A single message.* If the message to be communicated cannot be distilled down to one or two sentences, you are saying too much. How much is too much obviously varies from project to project. A book can communicate a longer, more complicated message than a postcard. But as a rule, the message must be understood quickly.

Before proceeding, you must evaluate the information that you have. Check to see if any information is missing—and that the information you have is accurate. Make sure you have a clear understanding of what the client is trying to say. You are ready to proceed if you can clearly and concisely define the following:

The client (the sender)

The audience (the receiver)

The message (the single, focused point to be communicated)

The client's motivation (the result to be achieved)

The audience's motivation (why they would want to act on the client's message)

The competition (who else is doing this)

The environment (what else is in the way of audience reaction)

The audience's desired response (cry, laugh, buy, propose marriage)

A CLEARLY DEFINED OBJECTIVE IS AT THE HEART OF ALL INNOVATIVE SOLUTIONS.

Defining the Objective

An objective is the desired result, or goal, of any course of action. In design, our course of action is projecting a message to a specified audience in the hope of obtaining a desired response from that audience. Since you develop the vehicle to deliver that message, you must know what you want the readers to do after they receive your message. Our objective as designers is to predict and to maximize the audience's desired response.

The project's objective works for you, the designer, on a number of levels. It helps you determine where to begin, and it helps to signal when you've reached the end. It is a great tool for finding and evaluating your approaches and your solutions.

Clarifying the Message

First Impression Positioning and Marketing Program

We were approached by First Impression, a medium-sized two-color printer, to develop a newsletter. The company was in a growth cycle, adding new employees, reorganizing, instituting quality programs, and expanding into a new facility with additional equipment. The company wanted a newsletter to keep the customer base informed of the progress of growth. As an example, the client showed me a copy of a newsletter featuring a rendering of the new building and a photo of the entire

Printing on a shoestring?

First Impression
Printers and Lithographers, Inc.

first **impression**

700 Touhy Avenue
Elk Grove, Illinois 60007

708 439 8600

At First Impression we cherish the miracles that can be created from a single sheet of paper. A 28" x 40" sheet of paper produces:

1 — **8.5" x 11" sixteen-page booklet**
about the life and times of Mr. Potatohead, or

2 — **19" x 27" life-size poster**
of your pet hamster and gerbil tanning at the beach, or

2 — **6" x 9" sixteen-page booklets**
describing the how-to's of taxicab and commuter bus safety, or

42 — **4" x 6" postcards**
offering your boss for sale, or

164 — **2" x 3.5" business cards**
which will cover everyone on a flight from Chicago to Juneau, or

1120 — **1" x 1" stamps**
depicting a few of the eliminated design alternatives for the 29¢ postage stamp.

Get the most from your one, two and three color printing with first.

FIRST CLASS MAIL
U.S. POSTAGE
P A I D
ELK GROVE, ILLINOIS
PERMIT NO. 716

wholly sheet!

staff. Through discussions with the owner, both of us came to the conclusion that the printer's customers were less concerned about the *progress* of the growth than about the *reason* for the growth.

You see, most printers expand from two-color printing immediately into four-color printing to increase profits and client base. But in doing so, they move from a niche featuring manufacturing strengths into a niche that is more complex and competitive. Further, the printer in the four-color niche tends to be more expensive and less focused on the quality of the less profitable work. First Impression, however, enjoyed the two-color niche and

wanted to expand its position in this market by focusing on all aspects of quality one-, two- and three-color printing. As a result, we developed a market positioning that projected a long-term view of the expansion as part of a commitment to the current market and manufacturing strengths: "First Impression, bringing life to printing with one, two and three colors."

Out of this positioning, we established a new identity and a three-tiered marketing program with all printed pieces folding to a unique mailing size. Each component in the program is focused on a single unique message that relates directly to the positioning,

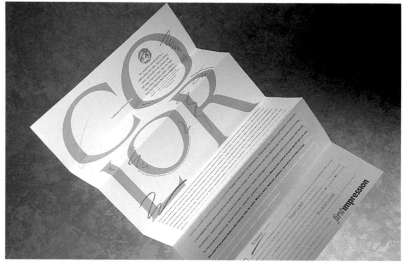

discussing issues of concern to customers, such as quality, creativity, service, knowledge and technology. The three types of communications used were:

- *Postcards* that are billboardlike communications with an immediate message stated boldly and creatively.
- *Theme-based newsletter* that is informative and entertaining without appearing promotional.
- *Special-purpose communications* such as moving announcements and Christmas cards.

The success of the program hinged as much on understanding the real needs of the company as it did on creatively implementing the program. It depended both on the client's understanding a long-term need for positioning and marketing, and on the client's appreciation for innovative creative approaches. And total success was achieved by evaluating all creative solutions against solid objectives.

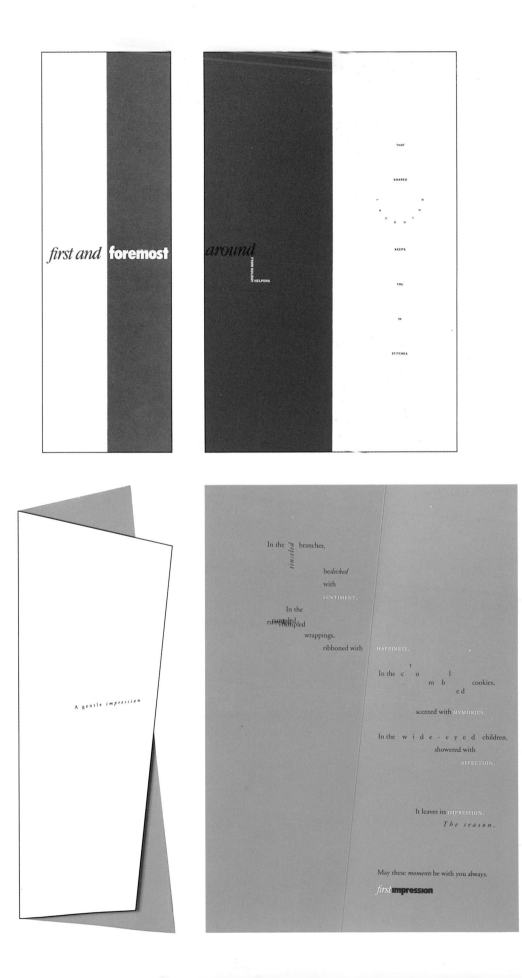

When a problem is successfully outlined, framed, documented and understood, it is easier to generate intelligent and thoughtful solutions. It is easier to find the unique qualities to the message. And it is easier to evaluate solutions that are unique and effective. A clearly defined objective is at the heart of all innovative solutions. The objective clearly and succinctly:

- States the essence of the problem.
- Provides a concrete way of evaluating solutions to that problem.
- Reinforces the stated objectives and goals of the organization as a whole.

This objective must be quantitative (can you measure its success?), realistic (are you asking a printed piece of paper to do too much?) and consistent with the client's other communications. This is where the time spent understanding your client pays dividends. If you don't understand the organization, you probably don't have a handle on the project you are discussing. You must understand what role this piece of communication plays in furthering the organization's greater goals and mission.

Within the context of the client's goals and mission, you must choose a focused objective for the project. Begin by deciding what the piece should do. Is it to inform or persuade the readers? A successful piece should not try to do both. If you are educating and informing your audience about a product, company or service, your design is likely to emphasize organization and *information hierarchy* (the relative importance of each level of information). Your design approach will, therefore, be more neutral and without emotion. If the goal of the project is to persuade the audience, to influence the audience's thinking and beliefs, your design approach will be more emotional and *subjective,* placing the emphasis on the *selling proposition* and *call to action.*

As you work on focusing your objective, make sure that the desired results are quantifiable and realistic. Determine how you and your client will know that the project has achieved the results you promised. What does the piece need to do? Motivate sales to generate a significant profit? Will the success of the piece be measured by the number of telephone calls or response cards received? Is the piece expected to change people's behavior? How will any of these factors be measured? What will define successful? A clear understanding of what the client expects from his audience will give you a clear understanding of what he expects from you.

Developing the Design Criteria

From the objective will spring a list of visual criteria that translates client, marketing and business jargon and language into design language. This means that you will take the agreed-upon objectives and translate them into terms that mean something to you, the designer.

The design criteria help you narrow the options and focus on a limited palette of creative approaches. The design criteria build on the project-specific information from the client. The design criteria summarize all visual and verbal characteristics dictated by the objectives that will directly influence the design approach, such as:

- Mandatory format and physical limitations.
- Production parameters.
- Qualitative issues affecting the audience.
- Function and purpose issues affecting the audience.
- Usage and longevity issues.
- Budget and schedule issues.

Some projects have very simplistic design criteria that are briefly discussed after the initiating meeting. Larger projects require the designer to review the background information, analyze the project objectives, and summarize the design criteria for review with the client. This process will help the client understand the impact of her objectives.

Spinning the Information

Now that you have determined the objective and audience for the piece and defined the desired results, you are ready to develop the unique, creative vehicle for this project. You will discover the value of all that information you've poured into your head when you get to this point. Now the objective becomes subjective. Now fact becomes metaphor and data become innovation and creativity. It's like putting all of the ingredients into a bowl. Now you get to add the spice.

IMAGINATION IS MORE IMPORTANT THAN KNOWLEDGE.

Albert Einstein, physicist

The information in your head is now portable. You can take it everywhere—the museum, the racetrack, the mall, the forest, the theater. You can open it up to other influences—books, music, art, experience, television. You can transport the information to a location you could not have imagined sitting at a desk with a white piece of paper in front of you.

Find your catalyst—the one thing in the universe that will influence the outcome of the project in a way that is unexpected yet consistent with the objectives. In the next chapter, we will explore many techniques for finding that catalyst for a particular project.

Just Wanting to Do Creativity

Noranda, Inc., Annual Report 1992/1993

"We show these annual reports to other clients and prospective clients, and every one of them says, 'Oh, these are wonderful, but I don't know how we could do something like this.' And I say, 'You have to want to do it.'" Diti Katona of Concrete Design Communications in Toronto says, "We are just regular designers. We bowl. We have fun. We eat like other designers, and our clients are regular people, too. We just have a clear idea of what we mutually want to accomplish, and we put our minds to it. There's no mystique. We simply understand our objectives."

Concrete Design Communications has been working with Noranda, an open-minded client, for five years, but the firm didn't start doing the annual report until two years ago. Katona says, "We were designing the employee magazine for those first few years. In those three years we helped them look at the magazine from the reader's perspective. We changed to the tabloid format after designing the magazine for a year because it presented information in a more digestible and understandable way. We printed the magazine on

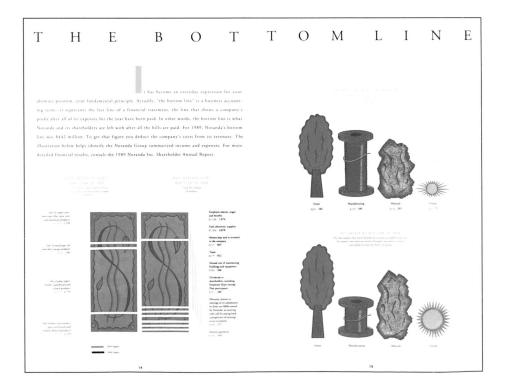

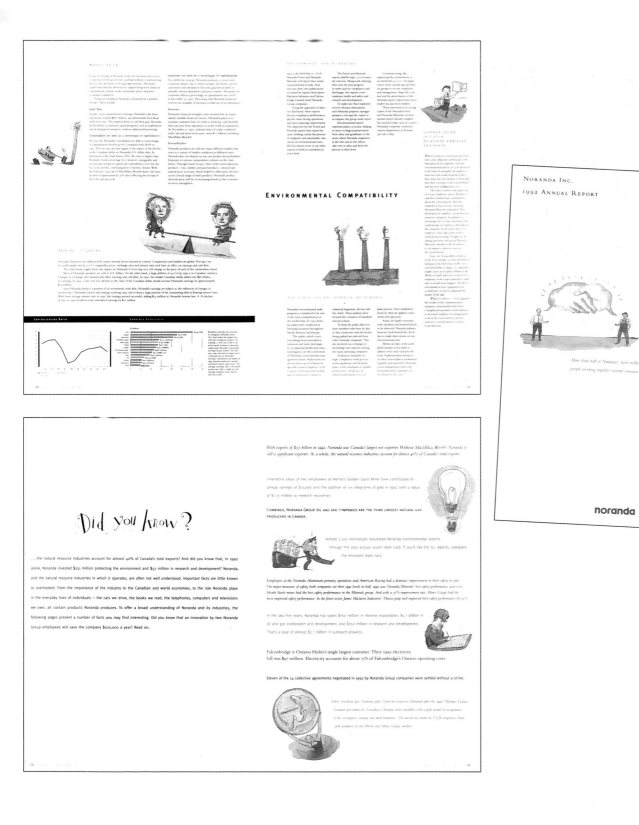

ENVIRONMENTAL COMPATIBILITY

NORANDA INC.

1992 ANNUAL REPORT

More than half of Noranda's $200 million earnings turnaround resulted from people working together toward common goals.

noranda

Did you know?

... the natural resource industries account for almost 40% of Canada's total exports? And did you know that, in 1992 alone, Noranda invested $251 million protecting the environment and $52 million in research and development? Noranda, and the natural resource industries in which it operates, are often not well understood. Important facts are little known or overlooked. From the importance of the industry to the Canadian and world economies, to the role Noranda plays in the everyday lives of individuals — the cars we drive, the books we read, the telephones, computers and televisions we own, all contain products Noranda produces. To offer a broad understanding of Noranda and its industries, the following pages present a number of facts you may find interesting. Did you know that an innovation by two Noranda Group employees will save the company $100,000 a year? Read on.

With exports of $3.5 billion in 1992, Noranda was Canada's largest net exporter. Without MacMillan Bloedel, Noranda is still a significant exporter. As a whole, the natural resource industries account for almost 40% of Canada's total exports.

Innovative ideas of two employees at Hemlo's Golden Giant Mine have contributed to annual savings of $10,000 and the addition of 115 kilograms of gold in 1992 with a value of $1.15 million to Hemlo's recoveries.

COMBINED, NORANDA GROUP OIL AND GAS COMPANIES ARE THE THIRD LARGEST NATURAL GAS PRODUCERS IN CANADA.

Almost 2,500 individuals requested Noranda environmental reports through the 1991 annual report reply card. If you'd like the '92 reports, complete the enclosed reply card.

Employees at the Noranda Aluminum primary operations and American Racing had a dramatic improvement in their safety records. On major measures of safety, both companies cut their 1991 levels in half. 1992 was Noranda Minerals' best safety performance over even Heath Steele mines had the best safety performance in the Minerals group. And with a 37% improvement rate, Mines Gaspé had the most improved safety performance. In the forest sector, James Maclaren Industries' Thurso pulp mill improved their safety performance by 52%.

In the last five years, Noranda has spent $700 million in mineral exploration, $1.7 billion in oil and gas exploration and development, and $250 million in research and development. That's a total of almost $2.7 billion in outreach projects.

Falconbridge is Ontario Hydro's single largest customer. Their 1992 electricity bill was $97 million. Electricity accounts for about 15% of Falconbridge's Ontario operating costs.

Eleven of the 14 collective agreements negotiated in 1992 by Noranda Group companies were settled without a strike.

Sylvie Fréchette gets Noranda gold. Upon her return to Montreal after the 1992 Olympic Games, Noranda presented the Canadian Olympic silver medallist with a gold medal in recognition of her exemplary courage and determination. The medal was made by CCR employees from gold produced at our Hemlo and Mines Gaspé smelters.

Noranda Inc. Annual Report 1993

Tools of the trade
Advanced technology, employee development and training, open lines of communication, responding to customer needs, environmental responsibility and quality asset building and replacement: these are the tools behind Noranda's commitment to competitiveness, for today and into the 21st century.

noranda

Noranda's own paper, something that hadn't occurred to the company before. It's not a great paper—a glorified newsprint—but it's recycled (manufactured before the recycled bandwagon started). These gestures began to speak to the employees beyond the words. Readership of the magazine went way up. So when Noranda was looking for a new designer for its annual report, we bid on it and got it. We had achieved a comfort level with the client that let us begin to suggest content approaches and to discuss conceptual directions."

In 1992 Noranda wanted to present itself as a sensitive natural resources company, working together with the consumer to use resources effectively. "It's not until you tell consumers that they probably own two or three hundred things that were made from Noranda resources that the message hits home. We added the same kind of thinking to the annual report that we had integrated into the employee communications. Tidbits of facts, short stories, and a friendly illustration style pushed the right buttons in the readers. The large format and the recycled paper manufactured by the company were also applied to the annual report for the first time, with a very enthusiastic response.

"In 1993, Noranda wanted to feature the employee as a significant resource to the company. We also examined how people read the annual report a little bit more this year. This resulted in new communications criteria: People read short stories, and they look at the pictures. So the Noranda people wrote a series of essays, and the images featured employees as models in conceptual illustrations. One image showed how different people look at and subsequently interpret a simple apple. Another image examined the reverse pyramid structure found in Noranda's management approach.

"The design of these pieces is very functional. It's not driven by style. Our environment, our studio, is the same way. It's comfortable and bright—not intimidating, ethereal or black. We're just designers. Some in our profession are just so caught up in being a designer that their attitude gets in the way. They bully the client into creativity. We invite them and guide them. We, along with the client, just do creativity."

A new dimension

Three-dimensional modelling helps reduce mine dilution and aids in mine design

Three-dimensional design software is changing the way Noranda companies look at mineral, oil and gas deposits. The software allows Noranda employees to work with a realistic 3-D perspective of underground deposits with dramatic success that is going right to the bottom line.

Mining dilution (the unintended mining of waste rock) results in an annual handling cost of $50 million for Noranda Minerals. So, improving the engineering of mines to reduce dilution has been a major priority. Noranda was the first company in the mining industry to use advanced three-dimensional modelling to integrate data from diverse sources. This enables engineers to create sophisticated images of ore-bodies and their surroundings, helping cut costs dramatically.

Traditionally, engineers and geologists based their understanding of underground shapes on two-dimensional slices assembled from drilling samples taken at regular distances. Two-dimensional renderings make it difficult to understand a deposit clearly, and to decide how to design a mine, or a gas or oil well around it. Noranda's computer modelling enables employees to construct three-dimensional images that show the complete ore and geological structure. These images often incorporate diverse information such as micro-seismic data to give an improved understanding of the underground environment.

Norcen and Canadian Hunter are among the leaders in the oil and gas industry in the combined use of three-dimensional seismic and horizontal drilling technologies. (See article, Techno-boom, on page 7.)

Although these techniques were originally intended to reduce mine dilution, utilities are now putting them to work in previously unimagined ways. Three-dimensional modelling helps in the design of complex mine components such as the location and size of mining corridors, vertical passageways, and the mining areas themselves. Significant direct savings have resulted from reducing the amount of unnecessary cutting work in mines.

There are other benefits as well; information on changes in a mine's design, such as mining area placement, can be shared simultaneously by the operation's geology, engineering and survey groups. Three-dimensional systems are now being used at 18 Noranda mine sites by more than 140 engineers and technologists.

Customer Employee President

Collaboration is a key to success in our business. The traditional corporate pyramid structure has turned upside down as open lines of communication are being developed between all levels of employees and customers. This allows us to respond quicker and smarter to the new challenges in our businesses.

Nikkelverk werks

Nikkelverk's culture recognizes the value of employee involvement, training, rewards and recognition

By tapping the intelligence and talent of its employees, Falconbridge's Nikkelverk refinery in Kristiansand, Norway, has had 13 years of continuous productivity improvement. The refinery has achieved this enviable record through a culture that recognizes the value of employee involvement, training, rewards and recognition. Achievements have been numerous:

▸ With little capital investment, Nikkelverk expanded capacity in its cobalt refinery in recent years from 2,000 tonnes to 2,600. Unit costs have been reduced by 25%.

▸ Various improvements in the processing of precious metals, including slow-cooling at the smelting operation, have resulted in an increase in precious-metals production of 23% and a unit-cost reduction of 26%. In addition, a new process recycles used copper from copper columns.

▸ A team of employees working together has created a copper-stripping machine which not only improves quality but makes the process safer and slashes costs. Now they've turned their attention to developing a similar machine for the nickel process.

As a measure of Nikkelverk's success, the company achieved international recognition for its quality control. In 1993, it received ISO 9001 certification, which covers most areas of quality control in the plant, plus in-house engineering and research and development.

NORANDA INC 1993 ANNUAL REPORT 9

Process: under control

Horne and Technology Centre team achieves results through cost-effective process control

Engineers at Noranda's Horne smelter and Noranda Technology Centre researchers together found a way to improve operations by using sophisticated computerized process control techniques.

One of the largest in the world, Noranda's Horne smelter in northwestern Quebec handles 750,000 tonnes of copper concentrate feed and recyclable materials every year. The grade of copper matte (an intermediate stage in smelting) tended to vary, partly as a result of varying consistencies in the process. So the Horne and Noranda Technology Centre team worked together to fix the problem.

Relying on in-house expertise, the team developed a cost-effective control process that takes periodic samples from the matte stream and cross-checks them with the feed. The process can adjust the inputs to make sure there is better quality and consistency.

The strategy, implemented over a number of years, has had numerous tangible results at the Horne, including improving operations at the plant, increasing annual throughput and ensuring more consistent results. One example of the program's success: furnace life at the smelter reached an all-time record of 498 days in 1993, thanks in part to the new process control.

Newton would be proud

Sir Isaac Newton's encounter with an apple revolutionized how we see the world. Employees interpret their surroundings in unique ways as well. By encouraging ideas from all employees Noranda is developing new solutions to everyday challenges.

A natural solution

Noranda scientists believe that bacteria could be put to work at mines

When researchers at the Noranda Technology Centre went looking for ways to curb environmental contamination at mine sites, they took a lesson from municipal pollution control experts. Municipalities have years of experience in treating sewage with biotechnology: pollution-eating bacteria. In a highly pertinent example of borrowing technology from other industries and tailoring it to resource-industry needs, Noranda scientists believe that bacteria could be put to work at mines.

There are two areas of biotechnology research at Noranda.

One is in the control of acids produced by mining wastes. Explosives used in mining create nitrates and ammonia wastes. In the lab, researchers showed that municipal experience with nitrate-controlling biotech can help control the explosives wastes. A pilot project at the Hemlo mine is slated for later this year, using very common and otherwise harmless bacteria found in backyard soil.

Noranda is also testing various kinds of natural "barriers" to isolate mine tailings and the pollution they can cause. When tailings are exposed to air, they can release harmful metals. By applying layers of natural soils, scientists may be able to form stable covers. These covers will be complemented further with either vegetation, water or sulphate-reducing bacteria. Tailings sites will become either meadows or ponds capable of supporting conventional and aesthetically pleasing biological environments.

Joining forces

Noranda works with governments, industry and other stakeholders committed to sharing concern for the environment

The environmental issues that Noranda faces are global. And global problems demand global solutions. To take part in the solutions, Noranda works with the World Industry Council for the Environment (WICE). WICE is an organization of 90 major international companies in 21 countries that works as a forum to promote scientifically sound and cost-effective environmental policies.

WICE, which was forged in February 1993, is committed to sharing concern for the environment by maintaining high standards of environmental management through the principles of sustainable development. Through WICE, Noranda works with governments, industry and other stakeholders in striving to meet these goals.

The issue of international trade and the environment is a good example of a complex issue where Noranda participates effectively internationally. A WICE task force has reviewed the challenges business faces in combining sustainable development with the need for unfettered international trade. The task force has prepared a set of principles on trade and the environment.

Noranda places great importance on co-operative efforts such as those being made by WICE, and shares WICE's goal to make business more proactive and strategic in its goals of environmental responsibility and sustainable development.

NORANDA INC 1993 ANNUAL REPORT 13

Getting
to
Ideas

I DO NOT SEEK, I FIND.

Pablo Picasso, artist

A HUNCH IS CREATIVITY TRYING TO TELL YOU SOMETHING.

Frank Capra, director

Okay. So all the information is gathered and rolling around

your head. You go for a walk or start swimming laps.

You're in the middle of dinner at a Mexican restaurant and

suddenly the ideas start flowing. What do you do? Let raw

creativity take over. Do a mind dump and play with the

ideas. This section will help you see the information in a

variety of ways. The information is processed, analyzed and

transformed into many forms. Words and images grow

from raw brainstorming and blossom into a seamless

presentation of collective thinking. Information turns into

idea, idea into concept.

Brainstorming Alone

Most often we are forced to create alone. This is the most difficult way to be creative. As one person, no matter where your ideas lead, you can only pursue the path determined by one person's experience and knowledge. Creative thinking is not impossible to do all by yourself. Picking ideas from your own brain requires discipline and a keen awareness of your thinking process.

Catching the Ideas

Write It All Down. It starts with the first conversation. Your client describes a communications problem and your brain clicks into overdrive. As the client talks, your ideas are already flowing. Not only are you listening to the specifics of the problem, but you are processing this information and generating ideas. Sporadic, unorganized, free-flowing thoughts jump out at you. And they keep coming throughout the creative process. *They must be recorded.* Write them down. Sketch, jot and scribble them, or package them neatly in a file folder for you to reference. Write down everything the client says, everything that comes to your mind, everything you see that stimulates a twist in how you think about this problem.

JUST BECAUSE YOU'RE NOT A WRITER DOES NOT MEAN THAT YOU SHOULDN'T WRITE.

The thoughts you collect fuel the final concept. Have you noticed that active projects are rarely absent from your mind? It seems ideas and concerns often surface when pen and paper are nowhere to be found. When that happens, do whatever you can to remember these thoughts. Capture them on scraps of paper that you throw into a dedicated project file folder. Even better, take a sketchbook or notebook everywhere you go.

The Sketchbook. A sketchbook is a great source of inspiration and a perfect record for ideas that develop out of a project. Make it your basic rule to carry a sketchbook everywhere you go. It should be glued to your fingers and serve as an extension of your mind.

It is easy, however, to forget a sketchbook. It's cumbersome when we have other things to carry, such as briefcases and schedule books. That's a sign there's a problem. Replacing a sketchbook with a time planner or a calendar suggests that you even schedule your creative time. Even worse, it

suggests that you don't have time to "waste" being creative; and that's a creative sin. Ideas often don't emerge during a scheduled time; you can start with a blank piece of paper and end with one. You could be better off scheduling a trip to the zoo and carrying your sketchbook with you.

 Record everything in a sketchbook. Draw, write, scribble, doodle while you're on the phone. Tape pieces of ephemera that you've collected or tidbits from magazines or newspapers into the sketchbook. Photographs? Mistakes that emerge from the copy machine or laser printer? Cut them out and tape them in. You'd be surprised what ends up in a sketchbook. Write. Just because you're not a writer does not mean that you shouldn't write. Jot down words, sentences, paragraphs, quotations, remembered conversations or overheard gossip. Describe landscapes that take your breath away or faces that you see on the bus.

Project File. Making a project file is the next best thing to carrying a sketchbook. This file folder is a "catch-all" for everything you've collected regarding a project. Of course your notes and background material for the project are collected here, but so are scribbles on napkins from dinner last night and a brochure you picked up at the airport that has an interesting color scheme. Get in the habit of collecting stuff that inspires you and saving it in your pocket. Then transplant the material into the file for use when you begin doing serious creative development on the project.

Project Notebook. The project notebook takes the project file one step further and should only be used for large projects. The project notebook helps you organize the material as you collect it. A three-ring notebook with acetate sleeves provides the framework for collecting sketches, photographs, objects and copies of objects as the project develops. The notebook format gives you the opportunity to arrange and rearrange the materials in different ways. It helps you to categorize the information. You can insert text and manuscript during copy development stages. A project notebook usually starts out as a random sampling of materials and evolves into an organized and edited collection to turn into a working idea.

More Is Better

When you're in the creative development phase of a project, it's important for you to keep the ideas flowing—good ideas, bad ideas, boring, hot or cold. Brainstorming is just what it sounds like: a storm of ideas to be caught, examined, twisted and analyzed. But you must have lots of ideas for this to work; that's why more is better.

Why Hasn't Anybody Done This Before?

Visual Symbols Library on CD-ROM

Clement Mok of CMCD, Inc. noticed that designers spend a lot of time seeking or a lot of money creating images of simple objects to be used as metaphors or illustrations. "There are a lot of misappropriated images out there with the advent of the new imaging technologies. I see designers spending hours searching through books and magazines for images they can scan and digitally manipulate into new images and layouts." It seemed to Mok there ought to be a better way to use the power of the computer to find and create these simple images. His thinking didn't stop there; it raced on to a solution: "Why not create the perfect and ultimate library of images, a library of quintessential icons of our everyday life?"

Mok thought of this product in the middle of a technology seminar. The idea seems so obvious, it's surprising no one has done it before. Mok's thinking ran something like this: "CD-ROM technology, which lets us store high-quality images inside a small package, has surfaced. The need is there. We know the market because we are the market. We use icons and metaphorical images all the time to illustrate difficult concepts. Stock photography and clip art have already gone digital. But simple, photographic images— silhouetted for easy use—that represent the iconic images impressed upon the minds of the masses aren't available. Nothing like this exists." Mok tried to sell the idea to other software developers, but to no avail. So he

did it himself. **CMCD, Inc. is creating and marketing a library of royalty-free photographs for use in computer and print environments.**

These images are not merely stock, full-frame photos of everyday items. Each object, meticulously researched and photographed against a white background, is silhouetted and ready to be integrated into presentations or layouts. The images are selected and photographed with a keen eye for detail. "We don't call it clip art. Designers have an aversion to the idea of clip art, but they spend hours turning pages of magazines and stock photo catalogs looking for the perfect jack-in-the-box. Have you ever tried to find the quintessential jack-in-the-box? You can't. They're collector's items. . . . Your idea of a baby's shoe is not available in stores today."

NOTHING IS MORE DANGEROUS THAN AN IDEA WHEN IT IS THE ONLY ONE YOU HAVE.

Emile Chartier, philosopher

THE BEST WAY TO GET A GOOD IDEA IS TO GET A LOT OF IDEAS.

Linus Pauling, Nobel Prize winner

Focusing on one thought, direction or idea will generate a limited supply of solutions. But mixing, honing and refining many ideas will generate an endless supply of solutions that can later be edited and reviewed against previously established criteria. Don't stop at the first idea—or the second, or the tenth, or the twentieth.

There is more than one solution to every problem. So don't stop at the one great solution. If you do, you will never know what might have emerged next. It is always the next idea you generate that is the most creative and original one.

Follow an Uncharted Trail of Ideas

The key to discovering a new and unique solution is to explore an uncharted path. The hard part is getting off the heavily traveled paved road. Once off the path, just follow your nose. While thinking about a particular design problem, go to the museum, airport, grocery store or better yet, someplace you've never been before. The further from the problem your source of ideas is, the more original the ideas. If you mine for gold in the same place over and over, you'll not find any.

Keep an open mind. If you look for it, you'll find it. How often do you go to a flea market without noticing most of the items on display? However, if you look for something specific, a salt and pepper shaker in the shape of a vegetable, for instance, chances are better that you'll find it.

Some of the greatest innovations have come from the connection of two unlike concepts. Much of current aviation technology is inspired by concepts found through close examination of plants and insects. The concept of military camouflage emerged from cubist art.

I FIND THAT A GREAT PART OF THE INFORMATION I HAVE WAS ACQUIRED BY

LOOKING UP SOMETHING AND FINDING SOMETHING ELSE ON THE WAY.

Franklin Adams, writer

Look to the Obvious

Get into the mind of a child. Whenever I visit my wife, a third grade teacher, in her classroom, I see the world from a different angle. When children are asked a question, their answers seem to be

obvious but still unique. Their questions are insightful and direct. Their minds are not colored with prejudice, politics, judgment or criticism. They simply look at things as they are.

The curiosity of a child generates the most innocent, obvious, naive and untainted thoughts. What does the first bite of ice cream taste like? What do you do when a big red ball is thrown in your direction? What do you feel like when you find a quarter on the ground? Translate these feelings—the curiosity, the innocence—to your point of view.

<div align="center">

BRILLIANT IDEAS ARE OBVIOUS.

Guy Billout, illustrator

</div>

Sometimes you cannot see beyond your own nose. You think in the same way everyday and get stuck in the rut that routine digs. You are afraid to veer away from this path because you have only found success on it. But remove all of your experience and expertise. Lose insight and knowledge. Come to the problem in an open and naive state of mind. Ask the client, and yourself, the obvious questions, the "dumb questions." This new point of view will generate a fresh cache of information that is clean and free of judgment. The information may seem elementary and obvious, but look at it closely and you will see gems of ideas.

I'm sure you can think back on many situations where you have seen a wonderful design solution that seemed so basic, so obvious, and yet appropriate for the situation. The beauty in these solutions is the obviousness of the problem and a direct and unprejudiced translation into a solution.

Empty Your Brain of the Obvious

<div align="center">

AVOID THE OBVIOUS, LOOK AT THE NEGATIVE.

Vittorio Costarella, Modern Dog

</div>

Now that I've told you to look for solutions in the obvious, I will also tell you to go beyond it. There is a subtle distinction between the two directions. If you sit with a problem and sketch the first idea that enters your head, the result will most likely be an "obvious" solution. The idea will be a culmination of all the information you have collected and many of the influences you have absorbed through the media, television, magazines, design publications and so on. The idea might be good, but it will probably not be unique. If it is the first thought you had, it is probably the first thought other designers, given the same set of information, might have. You, however, want to be creative, stand apart from the crowd, and have a unique solution to the problem you are working to solve.

Look beyond your nose.

Seeing Cliché in a New Way

DIFFA, Chicago Benefit Communications Program

The Design Industry Foundation for AIDS (DIFFA) in Chicago sponsors a fund-raising benefit every year. All benefit communications are produced using donated services, including the design and coordination. The political climate surrounding the elections inspired the theme "An All-American Ball." Robert Petrick of Petrick Design was asked to conceive and produce materials with an Americana theme for the benefit. The reasons that inspired this theme were the same reasons it had already become tired and cliché. Petrick and the designers in his firm began the arduous task of innovating within the constrained area framed by the theme and the task of soliciting all production services gratis.

Six weeks of extensive brainstorming at Petrick Design provided a large inventory of conceptual images related to the theme. Metaphor and symbolism filled the designers' sketchpads. But an umbrella concept to encompass all these ideas still hadn't emerged. This changed when Petrick attended the gallery opening of an artist/friend, Adam Brooks. Brooks' work is composed of clever manipulations of language, words and letters. Unique pairings of words and letters create interesting and unusual messages with double meanings. Inspired by Brooks' word play, Petrick began to manipulate the letters and representations of "USA," "AIDS" and "America." The morning after the gallery opening, the

YOU . US . A

An All American Ball | OUR STRENGTH IS OUR UNITY OF PURPOSE

"**YOU.US.A**" concept appeared in his sketches. Seeing strength in the clichéd use of stars and stripes, the designers and photographer François Robert started to twist and abstract these graphic elements. The resulting photographs, combined with the retitled theme **YOU.US.A**, became a kinetic and dynamic representation of the tired and obvious Americana theme.

The concept takes its ultimate form and true depth within the leather-bound keepsake program distributed at the benefit. Photography, design and writing interact in a discussion of both America and **AIDS** on two levels: reality and fantasy. Mixing fantasy— through poetry and imagery—and reality—through documentary materials and recitals of fact—drive home a conceptual and emotional message appropriate for the audience of benefactors.

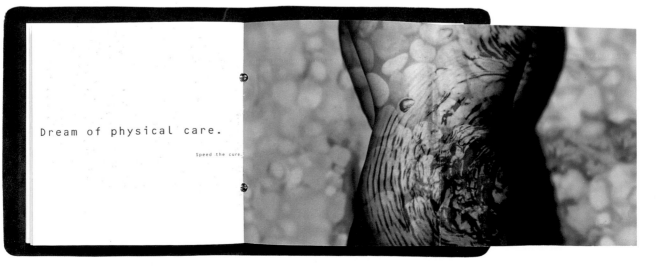

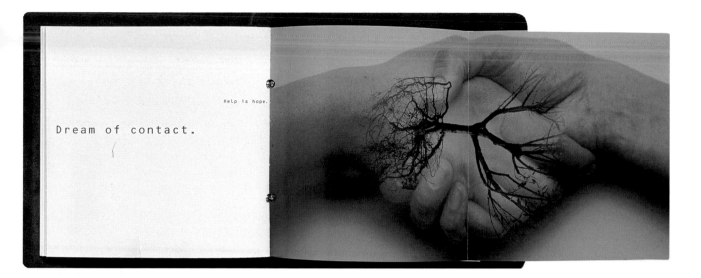

Help is hope.

Dream of contact.

Dream of sanctuary.

Illness, isolation and
fear are the constant
companions of the tired,
the weary, the homeless and the sick. For too many,
safety, security and shelter are still
only dreams. Hopefully,

refuge is near.

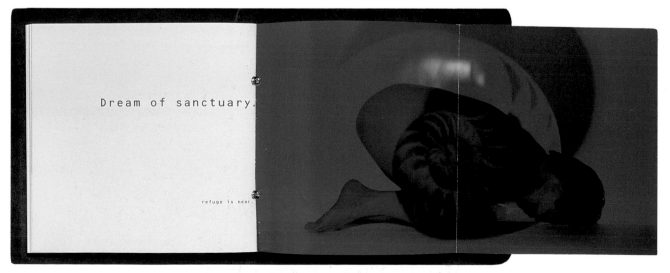

Dream of sanctuary.

refuge is near.

Change your state of mind before you approach the problem. One way is to get inside the naive mind of a child and look to obvious solutions without prejudice. Another way is to empty your brain of the solutions that come to mind without effort. These ideas might or might not be valuable. But once you have them recorded, you can go beyond them, produce other, less-apparent solutions, and evaluate all solutions side by side.

Know When and Where You Get Most of Your Ideas

The more you create, the more you understand the way your own mind works. Different people brainstorm and process ideas differently. Know what fires your imagination, and set the stage every time you are ready to create. Some people are morning people, some are evening people. Some people need to be in jeans and T-shirt to create. Others don't care. Some need total silence. Others are inspired by loud music.

I am most frustrated when my mind is working and my body isn't ready. There's the idea but no pen and paper to be found or, worse, I'm in the shower. Once you figure out how your mind works, you can be better prepared to capture ideas when they most often come to you. You'll also be able to prolong creative sessions beyond the limits of your internal clock. It is much easier to keep your brain on after it's clicked into gear than it is to crank it up from neutral or park. For example, adjust your work schedule to your creative style. If your ideas come at two in the morning, schedule your creative development for that time (and sleep in the afternoon). If you need grass and trees to inspire you, don't even try to brainstorm on the thirty-ninth floor of the skyscraper that houses your office. Once your internal clock switches the brain on for you, just keep going.

Give Yourself Some Parameters and Constraints

Any artist will tell you there's nothing worse than a project with no rules. It's like trying to paint the entire expanse of a limitless ocean. What part of it do you paint? As creative professionals, we spend many hours removing constraints, rules and requirements. We want more room to be creative. But a problem with no limits is really not a problem; there's nothing to solve. On the extremely rare occasions when I have had a client tell me to do anything I wanted, I instantly began setting my own limits. I determined the boundaries for the solution and created my own set of constraints derived from the client's objectives for the project. When the client has objectives, use them. Look to the intended audience and examine its needs. A landscape with edges is easier to paint than one without them. The edges define when the painting is done.

Combining Ideas to Make New Ones

We've discussed that you should record all ideas, regardless of their caliber or appropriateness. After you've generated many ideas, start putting them together. This in and of itself will not necessarily evoke great solutions; however, it may give you a different way of looking at both ideas.

IT IS MUCH EASIER TO KEEP YOUR BRAIN ON AFTER IT'S CLICKED INTO GEAR
THAN IT IS TO CRANK IT UP FROM NEUTRAL OR PARK.

Some of your best ideas will emerge from your mind's making unexpected connections. A basic creativity exercise involves combining two random words that have no relation to each other and building a bridge between the two. A variation of that involves combining a word and a picture selected at random. Look at the page-numbering treatment used in this book. Each page number has a randomly chosen word and picture next to the page number, integrating this exercise into the structure of the book. There is no planned connection between word and picture, but you can use the juxtaposition of the two to spark an idea of your own. This idea can become the seed for a fully developed concept. Try the same method with two miscellaneous thoughts generated by brainstorming. A connection you make could generate interesting and unexpected idea combinations that produce innovative solutions.

Extremes and Opposites

Get into the habit of looking at things from opposite sides. Sometimes we are so used to looking at an object from one side, we forget that is has any other. In fact, it may have many sides. It is important to look at an idea the same way. When developing a concept, try to come at the problem from the other end. The fresh perspective will give you new insight into the idea. If something demands to be white, try making it black. If something is normally stated in words, substitute numbers. If you have an image that is generally shown right side up, put it upside down. Don't keep a piece of type small, make it enormous. Design a piece that should move from front to back as one that moves from back to front instead. Exploring opposites can turn your first idea into many more.

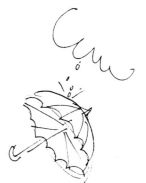

Facing the Fear of the Blank Piece of Paper

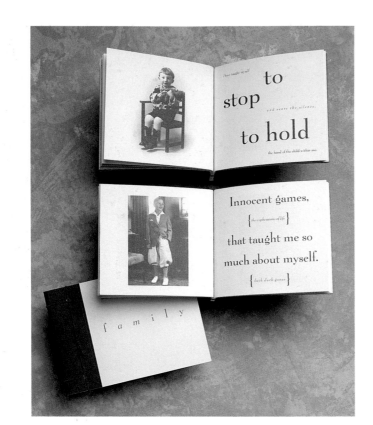

Mark Oldach Design Self-Promotion Program

What do they say about the Shoemaker's children? They are usually the ones to go without shoes. So goes self-promotion for design firms. It's not because designers don't understand the importance of marketing. It's not because they don't have the time to implement a self-promotion program. I believe it's because most designers don't know where to start. There's no budget, no schedule and, quite frankly, no stated message or objective. As designers we demand this information from our clients before we can start a project. Why don't we demand this of ourselves?

Mark Oldach Design has designated the Christmas card as the one opportunity every year to show clients and prospective clients what we can do. We are the client, and we make the demands. Instead of showing work for other clients to illustrate how we think, we build a message from scratch, doing for ourselves what we do for our clients throughout the year.

We start with a message that everyone can relate to. The holiday season provides a starting point, a vast framework within which to set each year's specific message. We meet our deadline and set an affordable budget. With these parameters, a field of options is quickly whittled to a focused message that moves readers to think and react.

Our first card, "Hark," was also our first collaboration with writer Linda Chryle. It proved to be the perfect interaction of writer and designer, producing a seamless presentation with a clear objective and focused message. I wanted to highlight the logo of our new design firm, but also present it in a way that would appeal beyond the purely promotional level. Our logo, a circle with the word Mark in the center, served as the starting point. The seasonal word Hark

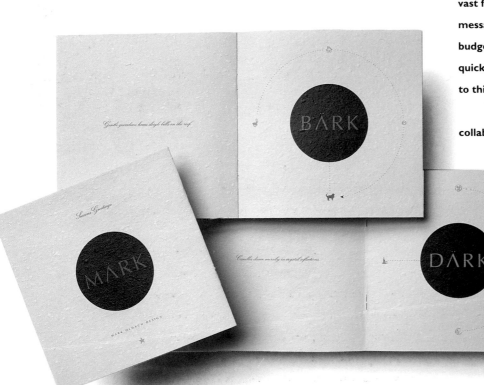

served as the end point, and rhyming words fell in between. We connected this list of words with other holiday- and winter-related words. Linda carefully crafted phrases packed with meaning and emotion, brimming with the holiday spirit. We then diagrammed these messages around each of the anchor words using graphic icons and flow chart arrows.

The second card, "Family," grew from the discovery of some exquisite old family photos I found in a chest of drawers in my parents' home. You can't buy this kind of photography today; photographic technology has changed so much that you can't capture the same kind of imagery. My desire to use these photos in some way became the catalyst for an interview between Linda and me. (After she interviewed me, I understood what I put my clients through.)

Out of this session came the concept that we would create an Everyman's memory of family through words and pictures. Linda created a list of phrases, impressions, words, stories and memories derived from our interview session. We edited each other's work, arranging and rearranging words while matching them with images. The result was a true collaboration.

"The Circle Widens," grew from my memories of the paper chains we made and hung on trees as children. I remember making them in school, at home or in social gatherings, but never alone. These memories led to the message of the community as a source of support for the individual; the paper chain would serve as the motivator for communal activity. It was the perfect follow-up to the previous year's card, "Family."

We designed the chain first. We created a book of preprinted and precut strips. Each page of three strips was a complete graphic statement. When removed from the book and assembled as a chain, the words, images and colors interacted to create a new presentation. To introduce the book, Linda wrote a short story about the importance of community. The book inspired hundreds of clients and colleagues to create 40-foot paper chains in their homes.

"Midnight," card number four, grew out of the

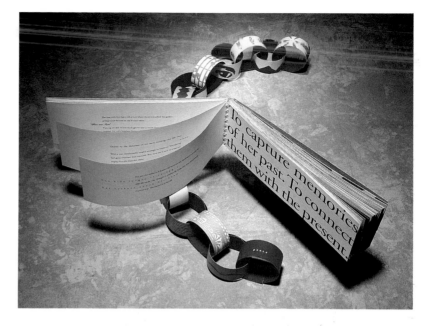

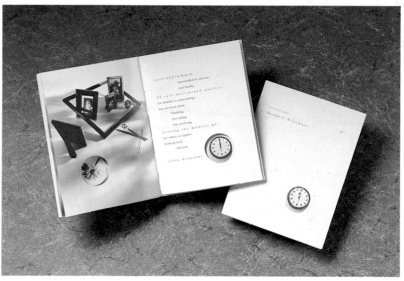

desire to extend our mailing deadline. We moved the focus from Christmas to New Year's Eve and the stroke of midnight. That theme led us to explore what midnight means to different people.

Linda and I imagined six different ages in life that inspire unique perspectives on midnight. Linda created a wonderfully poetic manuscript with insightful word play and metaphor. Our new creative partner, photographer Anthony Arciero, created surreal images that captured the mind-frame of the person examining the new year. Each of us added a level to the message that could not have been realized independently.

THE REVERSE SIDE ALWAYS HAS A REVERSE SIDE.

Japanese Proverb

EVERY STICK HAS TWO ENDS.

Michael Ray and Rochelle Myers, authors, Creativity in Business

YOU CAN EITHER BE UPSET WHEN YOU HAVE BURRS ON YOUR CLOTHES,

OR YOU CAN INVENT VELCRO.

Marc Steuer, Syntex

The "opposite" approach to brainstorming can be taken further. Point of view plays a key role in finding an effective solution to your communication problem. Sometimes it's appropriate to look at the problem from the big picture, an overview of the process or system. Sometimes it is best to focus in on the most minute detail to communicate the concept. This change in viewpoint will bring to light things you might otherwise have missed. For instance, "weather" can be communicated from a raindrop's point of view. Follow that drop through the water cycle, as it falls into the river, evaporates into the atmosphere, condenses into clouds and falls again. Or you can look at weather patterns from space—cloud formations indicating weather fronts and large-scale events. Both the micro and the macro view of the weather shows you something and can, in turn, lead to other words, images and concepts.

Another consideration is extremes. When you explore an idea, look at its most extreme version. This presents the idea in its purest form. You could also exaggerate some of its features. If the client asks you to use large type, use enormous type. If you should use little imagery, use none at all. If you discuss the desert in a book or brochure, fill a plastic bag with sand and staple it to the cover. Pushing a good idea to extremes can make it a brilliant idea.

Know When to Go for a Walk

Often I sit and think, reviewing my notes with paper and pencil in hand. As I read the notes and background information, the thoughts that enter my brain seem to have no meaning. Words remain words, never becoming concepts. I find myself looking for other things to do, such as washing dishes or gossiping with others in the office. I'm not thinking creatively. I have hit a brick wall and can't seem to climb over it. This is when I know it's time to go for a walk.

The symptoms of creative block are unique to each individual. We all have our own ways of avoiding the painful process of recovering. (It's really painful only if you try to force it.) But when

look at things from all sides.

you hit that point where you are not connecting with the project, drop it. It does not matter if there's a deadline looming tomorrow. If you continue to sit at the desk and try to force creativity, one of two things will happen:

1. You don't come up with an idea, or
2. You come up with an idea that is neither creative nor original, which you will guiltily present to the client. And the client will like it, a lot. So there you sit for the duration of the project, implementing a mediocre idea that fosters no passion or pride.

I derive most of my inspiration in flight—walking around, distracting myself, looking at and thinking about other things. Within minutes from walking away from the project, my mind starts to work again. When I find I have somehow gotten over the wall, I'm rarely sitting at my desk or holding a paper and a pencil.

Another method of overcoming the proverbial brick wall is to analyze the wall itself. This is an exercise in getting your mind off the project just long enough to unblock the flow of ideas. Some people call this creative technique "guided meditation." Whatever you call it, it's a way to get your mind thinking again. Let's use the brick wall as a starting point to see how this technique works.

The brick wall is a metaphor for the creative block every artist or creative professional runs into. Let's spend some time examining it. Visualize the wall. What color is the brick? Where does it stand? Does the brick have any cracks in the mortar? Is it an old wall? Is there graffiti or ivy? Are there any holes, doors or windows? Last but far from least, what's on the other side of the wall, and why is what's on the other side so important?

Now let's step back from the wall. It's time to start solving our problem with it. Look for an opportunity to get through, over, around it. Are there any loose bricks? If there are, we can pull them away one by one to create an opening. Do anything you can to get to the other side of the wall.

Once on the other side, stop, look around, and record everything you see—everything. Now quickly go back to thinking about the problem you were trying to solve when you hit the wall. Draw any connection you can between what you saw on the other side of the wall and the project you were thinking about. Use the connection as the starting point for a stream of ideas. If nothing comes, back up a few steps and follow another stream. Following streams of ideas to unknown destinations is the source of good creative thinking and problem solving.

breaking
through
the
brick wall.

Brainstorming in a Group

everyone participates

assign a facilitator.

There are never too many minds during a brainstorming session. Raw brainstorming is always most successful when several people get together with sleeves rolled up and minds open. Where one person may hit his head on a wall is the exact place another person finds a window of opportunity. Verbalizing ideas in a group is the best way to take ideas beyond what you thought to be possible.

Remember, we are discussing brainstorming in a group—creating creativity. We *aren't* discussing the creation of a committee to evaluate ideas or approaches. I am suggesting that you assemble a team to generate ideas, because it seems the best ideas are generated by groups. On the other hand, ideas are best evaluated by only a few and, ideally, by only one person.

There's a real art to team brainstorming. It's a lot like group therapy. You must keep the ball rolling, pick up steam, bounce thoughts off each other to facilitate great ideas. Here are some basics to keep in mind while brainstorming in a group:

- Everyone in the room is an equal participant. No one is the boss, and no one is stupid. Mutual trust and respect for all group members will produce better results.
- No ideas are bad. There is no judgment or evaluation of ideas. All ideas are significant and will lead to others.
- Record all thoughts, statements or ideas. These sessions are best recorded by one person on a roll of paper hung on the wall for everyone to view. This way, old ideas are as close as the new ones emerging. Further, if something is not recorded accurately, at least one person will notice and correct the error.
- Start the brainstorming session with an examination of the problem. Developing a verbal description of the problem will start the ball rolling.
- Always restate the problem in terms other than those in which it was originally described. This causes you to look at individual words as a source of inspiration.
- List words that have anything to do with the issues at hand as a means to discover and explore possible paths to new ideas.
- Silence is bad, noise is good. When the room is silent, there are no ideas and you are pursuing a dead-end thought. Move on.
- Everyone participates. Group dynamics affect different people in different ways. Remember the quiet kids in the back of the classroom who didn't raise their hands? Many of those kids had, and still have, the most creative minds. They're simply afraid of

looking foolish. If everyone in the group plays fair and remains open, these people will participate. If they don't participate, call on them. Ask their opinions.

- Assign a facilitator. Notice I avoided the label of "leader." The facilitator is someone who keeps the group talking. She is not the evaluator, nor the one with all of the ideas. The best facilitators are often the people who are generally quiet when in a group. A quiet person serving as facilitator will be more motivated to contribute.

- Brainstorm when everyone is fresh. Don't do it the first thing in the morning when some people are trying to wake up. Give them time to get the cobwebs out of their heads. Don't brainstorm at the end of the day when everyone is tired and drained.

- Avoid interruptions. Have someone outside the session cover the phone and take messages. Do not, I repeat, do *not* interrupt the session for anything.

- Keep the tone of the session light and playful. If the room lacks fun and laughter, chances are the ideas are dull, uninspired and predictable.

Create a Haven for Innovation

A sterile environment begets sterile thinking. You can only be innovative where you feel comfortable and nourished. A creative haven has two essential characteristics:

1. It's fun, comfortable, physically enjoyable and stimulating.
2. It's open to risk and has no hierarchy; it's nurturing and tolerant.

These characteristics often are missing from organizations with rigid structures, whose attitudes tend to be, "Risk is bad and safe is good." On the other hand, small organizations where team members are creative peers make it easier to be creative.

Why is having a haven for creativity so important? Almost everyone who has achieved success as a designer will say that success hinges on having self-confidence and no fear of failure. In other words, they can take risks without criticism or judgment. Talk to any creative professional, and you will learn that the freedom to take risks is the fundamental reason their work stands out.

Every designer needs a haven for innovation. If you work for someone else and find you're afraid to take risks or have your ideas judged, you won't do your best work. If you work alone but don't present your most creative work because you're afraid of your client's reactions, you deny yourself the haven you need.

How do you create a haven for creativity? First, get rid of negativity. *No* is not part of the language of creativity. *No* breeds fear. "You can't do this." "I don't like that." "That doesn't make sense." "The client won't go for that." All these negative reactions break the creative spirit.

havens for innovation are comfortable...

...and free of negativity.

big creativity
from
small
starts.

Instead, encourage further development of potentially risky ideas.

Don't edit until the brainstorming session is over. Judgment and evaluation are big parts of the creative process, but they have no place in the brainstorming process. Judgment simply stifles further creative thinking. Remember during brainstorming, no idea is a bad idea. (We'll discuss the timing of and rationale for judgment and evaluation on pages 82–83.)

Creative havens are fun, interactive, lively and interesting. Stimulation in the forms of books, magazines, visuals, sound and music all make for innovative havens—and innovative people. If you don't like the people you work with, you're in a heap of trouble (especially if you work alone). Creativity demands a positive point of view, and the people around you determine that view.

SOMETIMES CREATIVITY COMES IN THE FORM OF THE SMALL "AHA," NOT A LARGE ONE.
Kris Clemons, Gerhardt & Clemons, Inc.

Look for the Creative Potential in All Projects, Big and Small

Not all projects offer obvious opportunities for creativity. It's easy to create for a creative project such as a poster, a book cover or an invitation. But try to be creative with an order form. A truly innovative designer treats all projects as opportunities for creativity. Even projects for difficult clients with closed minds should be treated with a uniquely creative touch.

My design firm was working with a client group on a registration package for an annual meeting. The ideas we presented were conceptual but way beyond anything they had done for past meetings. They liked our ideas but were uncomfortable with the aggressive conceptual approach. "The audience isn't ready for change," they said. I asked how our approach was different. They listed numerous incidental concerns such as the organization, format, and presentation on the page.

They also mentioned the aggressive integration of the concept. It made the client group nervous. "Just give them the information," they grumbled. "And the registration form; it's different." With that as a lead, we focused the conversation on the form. We had carefully considered how to make it easy to use and how best to organize the information on it. Explaining that aspect to the client group let us demonstrate the amount of thought that went into the whole piece. We walked them through the reader's process and the reader's need to understand the questions being asked. We could see them changing their tune as they realized how much easier it was to understand this "different" form. The other issues were never discussed further. And it turned out to be the client's most successful meeting to date.

Merging Words and Images

The words within a creative communications solution are perfectly married to the image. Both are symbiotic to the significance and meaning of the message. In some cases the words lead the creative solution. In other cases the images lead the message. Sometimes words and images are equal partners.

A designer's first instinct is to focus on the visual aspects of the message. Our training has been focused on visual approaches, and our professional strengths lie in the creation of images. Most of us have taken more courses in painting and drawing than in writing; many of us became designers because of a strong passion for drawing or painting. Conversely, we often have a fear of writing. It doesn't come easily to us. We are frightened by a grammar monster that scratches at our creative ego.

But as a designer, you have a responsibility to embrace words as much as images. Too many designers believe that their only responsibility lies within the visual portion of the solution. Think again. As designers, we work with many tools. Typography is one of those tools. Just picking the typeface isn't enough. How the message is conveyed and interpreted through typography determines the success or failure of the design.

The successful and creative concept lies within both the words and the images. Words give you the ability to communicate concept. And words often drive the concept. The best way to find a solution to a communications problem is to spend a lot of time examining and studying words, working creatively with the writer, and to push the potential for creativity by manipulating words. Many brainstorming exercises discussed in this book involve words as much as images and design elements.

I don't suggest that you take on the responsibility of writing yourself. What I suggest is that you get involved in the writing phase enough so that you can marry the words with the images effectively. An appropriate marriage of words and images seldom occurs when a designer views only a finished manuscript. This approach generally does nothing more than promote simple decorating around words. Instead, try to get involved earlier in one or more of the following ways:

- Involve the writer and yourself in the brainstorming process together. Your strengths will complement each other's and facilitate a perfect symbiosis of word and image.
- Review a draft of the manuscript and, if possible, an outline. This will give you a clear idea of where the writer is coming from, strategically and organizationally.
- Involve yourself in the editing process. If the client and writer are involved in the design process, it will be natural for you to be involved in the editing process. Remember, creatively speaking, several heads are better than one.

merging words and pictures.

Words Used as Images

Andersen Consulting, Marketing Brochure for the Technology Assessment Group

Closer Look Creative Group asked Mark Oldach Design to design a brochure it was writing for one of Andersen Consulting's business units. The Technology Assessment Group analyzes and follows technology to develop perspectives on how to apply current and emerging technologies in business and commercial settings. Internal and external clients take their reasoned thinking and integrate it into future planning. The group wanted its clients to understand the benefits it provides and to utilize the results of its analyses.

The writing drove the concept in this case. Specific points were to be communicated. The material and the technical terminology were complicated and hard to understand. The audience could easily be overwhelmed by the task of trying to absorb and understand the message if the copy was presented in the form of running text. We let the information—the content of the message—influence how it would be presented. So we diagrammed the text.

We tried to get inside the minds of the Technology Assessment Group consultants and then diagram the information we found. For example, the group has a distinct three-phase analysis process that was dissected and presented on three sequential spreads. The thought processes and points of analysis are broken into text bites. We strategically arranged them on the page and connected them with arrows and other flow chart symbols to help readers understand the process and the definitive, available outcomes.

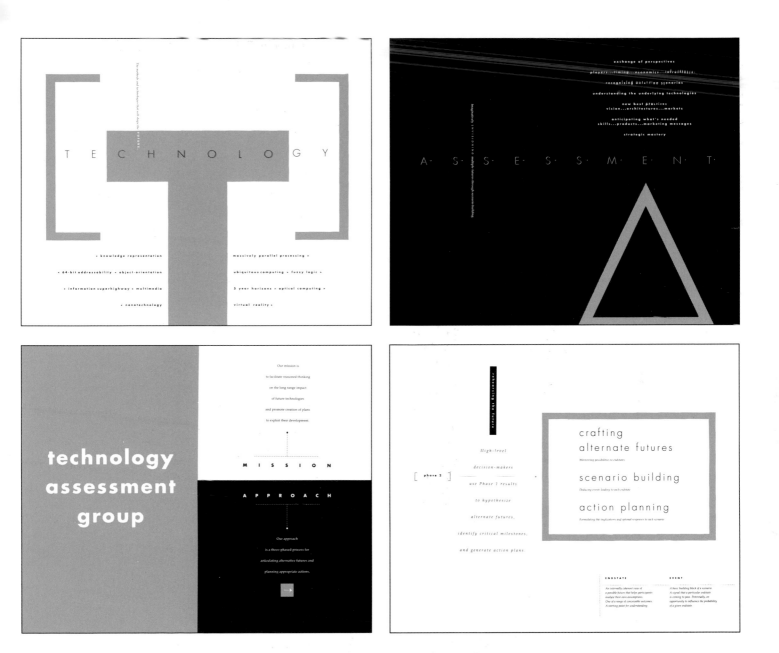

The information is presented in a simple, direct, approachable manner. There are no pictures, no visual gimmicks—just an image of the information as it enters and exits the brain. We present the group as a composite of its mission, its definition, its process and approach, and its results. If you read the brochure from cover to cover, you'll get a comprehensive view of how the group thinks and the processes it goes through. But even if you don't read the copy in a linear fashion, you still get the message.

- Discuss the design development with the writer. Just as you might have significant insight into words, the writer will have significant insight into pictures.
- Present the writer and yourself as a creative team to the client. The client is consistently concerned about the message of the piece, hence he has strong input regarding content for the writer. He will tell the writer information that he might not think important to you. When you're a team, you both hear the same valuable information.
- Present the rough layout with the draft manuscript, and the finished layout with the final manuscript. If they're presented separately, they'll be evaluated separately. All of the effort you've gone through to incorporate content and concept into the design can suddenly be reduced to an evaluation of it as decoration.

We do run into clients who hand us manuscripts that they say are finished and cast in stone. We run into this practice no matter how we all try to avoid it. It happens less often, the more experience and trust you develop with a client. When push comes to shove with that finished manuscript, you still have options.

- The words may be cast in stone, but how you emphasize the words can be controlled through format and typography.
- Organization can be reinforced or even altered if presented to you with the potential for improvement. Working with typographic hierarchy, sentence, page and paragraph breaks, color zones and physical formatting will all influence words and their organization.
- Even in cases where we're informed that words will not change, we still can present a variation of a concept that takes liberties with the words. Always do this cautiously, and tie it directly to the concept. If you show them that their words will work but the piece would be better with different ones, they might be more likely to involve you earlier in the process next time. The client needs to know you have insight that makes it worthwhile to include you in the writing. But she won't know this unless you show her.

Creative Word Play

Let's look at how words facilitate creative thinking in the designer.

Collect Words

Brainstorming sessions often start with an examination and review of the problem, developed into a verbal description of it. Create a list of words and phrases that boils the problem down to the essence of what needs to be communicated. This list can include emotions, directions, facts, components, characteristics or instructions. It can be a summary of problems, audiences, or pros and cons. You can list anything having to do with the issues at hand.

Lists are devices to discover and explore paths of thought. Every word on a brainstorming list creates a series of mental images that will be affected by each person's experiences, vision and memories. The mental images impose themselves onto the words and twist the message in a different direction. When verbalized, these new messages bring to mind a whole new set of messages—more words, more images, more thoughts. The cyclical process of brainstorming takes over.

We have discussed the importance of moving along an unexplored path to generate ideas that are unique and fresh. This process does just that. The following are a few conceptual directions in which words can take you:

Think in Opposites. Thinking in opposites will impose a different point of view on any idea or word. Looking inward from a doorway provides you with a very different vista from standing in the same doorway and looking outward. ("Time stands still" reverses to "Time is fleeting.")

Color Words. Colors contain a lot of meaning and emotion. Translating that meaning into words without the benefit of image or graphics can sometimes be very expressive. Color speaks to different people in different ways. Let the words work for you. ("Are green eyes jealous or are they the color of money?")

Animate the Inanimate. Attach human qualities to inanimate objects or abstract ideas. This can be done in a variety of ways, such as:

- applying emotions to inanimate objects (a happy Rolodex)
- giving physical characteristics to inanimate objects or ideas (walls have ears; cancer is a silent killer)
- applying action words (running with an idea or slapping fate in the face)

Word Play Adds Punch to the Message.

Step 2 Identity and Kick-off Event Invitation

Steppenwolf Theatre Company is a dynamic and aggressive Chicago ensemble theater group. It has developed a reputation for its raw and emotional approach to presenting plays. The company wanted to launch a group that would attract the interest and support of a young, smart audience, a different group than the majority of its subscriber base.

Steppenwolf approached Mark Oldach Design to develop an invitation for the new group's kick-off event. They gave us copy that was a rehash of standard event invitation language, the "we cordially invite you ..." kind of thing. The message was appropriate for traditional patrons of the arts, but it wouldn't attract the intended audience of cynical, sophisticated twenty- and thirty-something urban professionals.

We felt there was a connection between the cynicism, anger and curiosity that seemed to characterize this audience and the aggressive, emotional work that Steppenwolf presented. Like many popular movies and the lyrics of contemporary rock and rap music, the theater's productions are filled with outward, physical expressions of emotion such as biting, scratching and kicking. The word kicking suggested a way to connect the style of the theater's productions and the type of event, a "kick-off."

We basically rewrote the copy using aggressive words such as rip, scratch and beat that could have appropriate double meanings. For instance, beat can suggest two people hitting each other, but beat is also used in the sense of "beat others to a unique opportunity" by joining this group. The theater's productions only "scratch" the surface of your involvement. "Rip" off the response card.

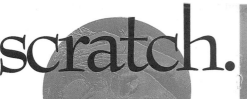

scratch.

WE'VE ONLY SCRATCHED THE SURFACE.

FOR SEVENTEEN YEARS, STEPPENWOLF HAS

sharpened

THE EDGE OF CHICAGO THEATER.

SINCE ITS INCEPTION, STEPPENWOLF HAS

ripped AWAY CONVENTION,

EXPOSING ITS RAW INNOVATION TO

A NATIONAL FORUM RESULTING IN

THREE **tony awards.**

NOW WE'RE EXPANDING THAT ENERGY

TO INCLUDE **you** THROUGH STEP 2.

SCREAM INTO THE FUTURE.

AS A STEP2 MEMBER YOU WILL

expand YOUR ENTHUSIASM

FOR THEATER WHILE BUILDING THE

AUDIENCE OF **tomorrow** WITH:

* BEHIND THE SCENES ARTISTIC PROGRAMS

* INVITATIONS TO STEP2 ANNUAL EVENTS

* TWO COMPLIMENTARY TICKETS FOR AN EVENING

 OF THEATER DURING THE 1993-94 SEASON

* VIP TICKET PURCHASE AND EXCHANGE PRIORITY

* SPECIAL INVITATIONS TO STEPPENWOLF PLAY

 READINGS AND WORKSHOPS

* VIP RESERVATION SERVICE AT SELECT

 LETTUCE ENTERTAIN YOU RESTAURANTS

scream.

BEAT THE MASSES...

join STEPPENWOLF TO

CELEBRATE THE KICK OFF OF **step2**

AND THE SPECIAL PREVIEW PERFORMANCE OF

"DEATH AND THE MAIDEN"

ON FRIDAY, JULY 16, 1993 AT 8 PM.

STEPPENWOLF THEATRE COMPANY

1650 NORTH HALSTED STREET, CHICAGO.

beat.

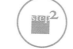

KICK OFF INCLUDES A PREVIEW PERFORMANCE OF

"DEATH AND THE MAIDEN"

AND A STEP2 DISCUSSION WITH CAST MEMBERS

GARY COLE, JOHN MAHONEY, RONDI REED,

AND DIRECTOR RANDALL ARNEY.

A PARTY WITH THE CAST, DIRECTOR, AND

STEP2 MEMBERS WILL FOLLOW THE DISCUSSION.

RESERVATIONS ARE LIMITED.

PLEASE RESPOND BY JULY 8, 1993.

STEPPENWOLF THEATRE	STEP 2 KICK OFF EVENT COMMITTEE	STEPPENWOLF ACTING ENSEMBLE	
STEPHEN EICH MANAGING DIRECTOR	JONI CHECCHIA	RANDALL ARNEY	TIM HOPPER
	KAREN DAUGHERTY	ARTISTIC DIRECTOR	TOM IRWIN
JUDITH SIMONS DIRECTOR OF DEVELOPMENT	JULIE HANAHAN FOLEY		TERRY KINNEY
	CHARLES KATZENMEYER	JOAN ALLEN	JOHN MAHONEY
	KATE LEWIS	KEVIN ANDERSON	JOHN MALKOVICH
STEP2	MAGGIE LEWIS	ROBERT BREULER	LAURIE METCALF
	BOB McCULLOUGH	GARY COLE	AUSTIN PENDLETON
LAUREN ESSEX CHAIR	MARK OLDACH	FRANK GALATI	JEFF PERRY
	GILLIAN O'NEILL	FRANCIS GUINAN	RONDI REED
	LEAH ROBINSON	MOIRA HARRIS	MOLLY REGAN
	BARBARA SUSIN	GLENNE HEADLY	GARY SINISE
			RICK SNYDER
			JIM TRUE
			ALAN WILDER

**By joining the new organization, the audience
would get the opportunity to rub elbows with the famous
actors who appear in the theater's productions. To
convey that message within the overall theme of the
piece, we used production photos of emotional scenes by
performers such as John Malkovich, Laurie Metcalf and
John Mahoney cropped tight to their faces and printed in
aggressive colors.**

money
grows.

Identify Categories. Ideas tend to formulate in groups. Look at your notes from your initial brainstorming. Group together ideas that tend to be similar or overlap. Label these, and then expand on them. (For instance, brainstorming for the development of a Christmas card will produce a whole bevy of seasonal symbols. Many of the items on the list might be items that contain the color red. Expand on that list).

Grow Metaphors. A metaphor is a figure of speech that gives you the ability to describe an abstract concept in concrete terms or to relate something complicated in simple terms. It transfers the characteristics and qualities of one subject or object to another to increase understanding. Metaphor connects two different universes. It builds on the similarities between two different sets of specialized vocabularies. The metaphor *a seed of an idea* implies that the idea will grow.

Any subject is replete with metaphor. Money grows (banking and finance using nature as metaphor). There's a storm front coming (weather forecasting using the military metaphor). Giving birth to ideas (motherhood describing the creative process). The list goes on. For every subject you discuss, there are a thousand metaphors. And each metaphor opens an entire new language to help describe the solution to the communications problem. Each metaphor projects a thousand images. Combine these images with other words, and you've discovered a unique way to communicate your message.

WE ARE CREATURES WHO DEAL WITH METAPHORS.

BE CONSCIOUS OF HOW THINGS ARE LIKE OTHER THINGS.

Todd Lief, writer

Double the Meaning. Comedians make a living using puns and double entendres to give funny twists to simple phrases. This same tool can be used to twist the message in a humorous and attention-getting manner.

Listen to the Words

The style, meaning and even the sound of words can differ between when they are spoken and when they are written. This is a key reason group brainstorming is better than going it alone; words sound different when spoken aloud to someone else from when you write them down on paper. Record a conversation between yourself and another person and play it back. Now transcribe a portion of that conversation. Note how different the tone, sound and pacing appear. That same difference can add a dimension to your communication, too. A conversational tone strips away formality. A written tone can add integrity. Use these variations to enhance, or to contrast with, the visual approach.

words words words words words words

Organizing With Words

After you have a clear and creative verbal approach, make sure it is understandable, even for the most simple-minded audience. Humor and metaphor may be wonderful methods to grab your audiences' attention, but if they can't be understood, or if the audience must spend too much time trying to get to the heart of a clever message, you've failed as a communicator.

Using words with design and concept to help establish a clarity of information and hierarchy of information will help the client accept the unexpected. Words that help meaning and understanding, organization and clarity, can be emphasized to direct the reader through the important information. It's not difficult to convince a client to accept a creative and somewhat risky design approach if it's rational and the organization of the information makes sense and is easy to understand.

Exploring Images

Words drive content. Images drive perception. This is why we develop both at the same time. We have just spent some time looking at words on a raw, creative level. Now let's look at images. Designers deal with image on two levels:

1. Through pictures, in the form of illustration or photography
2. Through design elements such as typography, borders, grid and color

The two are inseparable. When you derive a visual tone from content, then image, type, color and grid seem to evolve together. This is good. It continues the pattern of seamless creative development started by the writer and the designer working together.

The seamless presentation of visual elements has been furthered by the introduction of the computer. Now the designer can combine all the tools and elements—words and pictures, type and color, borders and images—at the stroke of a key or the click of a mouse.

Although seamlessly integrating type and image is important, you don't have to superimpose your typography on top of a collage of images every time just because the computer lets you. Don't allow the tool to drive the design. Content must drive the design. Look to the content for the image, the message and the design. Use innovative approaches to visual brainstorming to ensure your ideas are both creative and communicative—not merely trendy or decorative—to achieve true integration of word and image.

DON'T ALLOW THE TOOL TO DRIVE THE DESIGN. CONTENT MUST DRIVE THE
DESIGN. LOOK TO THE CONTENT FOR THE IMAGE, THE MESSAGE AND THE DESIGN.

Champion Paper "Imagination" Series

The Champion "Imagination" paper promotion series has become a collectible in most design libraries and an icon of American design. James Miho, who spearheaded the program for twenty-three years, describes the beginning of the project.

"In 1965 Champion Papers was in the red and sinking, and I was naive enough to think of paper as a medium that everyone uses. The competition for the attention of the paper specifier was unbelievable, and no one knew of Champion Paper. The Vice-President of Marketing, Edward Russell, was charged with getting the company into the minds of the specifiers, and quick. Everyone's neck was on the line. I was the fifth designer hired to handle the job; the others either quit or were fired.

"In 1965, this country had a local mind-frame. But there were global changes in culture, communications, satellites, arts and politics. I noticed a new country on the front page of The New York Times every day. The direction for this program seemed obvious to me: We go global (1965 was long before global became a hot marketing buzzword). I developed this idea in the middle of a conversation with Mr. Russell, but I needed support before I presented the idea. So I commissioned some market research. People thought I was crazy spending $60,000 on interviews with and about paper specifiers." But this research did help to define who paper specifiers were and what motivated them. It also clearly indicated that Miho's idea was right on target.

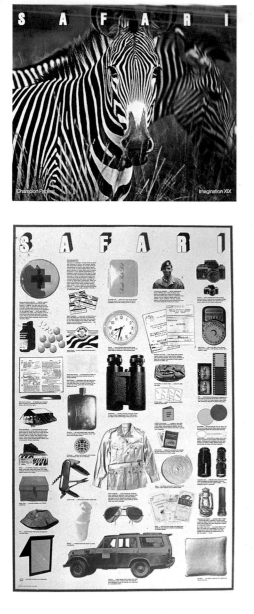

"I knew my approach was not a design solution, but an idea solution. I presented the idea with words so the group could imagine its potential in their own minds. It took them two minutes to give me the go-ahead." Miho's proposed idea was to let specifiers travel the world through a series of books that would let them explore art, geography, politics, people and cultures. The visuals would spark the reader's imagination, while the production of the promotion pieces would demonstrate the flexibility of and imaginative uses for Champion's papers.

"I worked with a team of writers to develop each piece. I always work with writers to create ideas with words and images. Substance is so important. As for the images, this program was the perfect application of the things that inspire my own creativity. Architecture, for one. Scribbles of artists, Dada, surrealism, gardens in Japan, shrines, signs and, of course, people like Louis Kahn. The Renaissance period in Italy, the Sung Dynasty in China, the prints of Hiroshige, and Murray Gell-Mann, the quark physicist from Cal Tech. Writers like Nabokov, Reischauer and Fairbanks. The Museum of Folk Art in Santa Fe, the Pitti Palace in Florence. The art and tales of Genji, Japan. Haiku. And the writings of [Richard Saul] Wurman."

Each addition to the "Imagination" series became a statement on the subject that the images represented. The images, in many cases, replaced words. Miho traveled to photograph most of the images himself. He collected a library of images that continues to serve as inspiration for his current projects. And, of course, they serve as inspiration for his role as teacher at the Art Center College of Design in Pasadena, California.

doodle

Doodle and Sketch

Doodling and thumbnail sketching is by far the best way to generate a lot of unique visual concepts quickly. Doodling is therapeutic. Doodling is done while your mind is meandering in other directions—while you're on the phone, for instance. Amazing visions begin to appear.

The beauty behind doodling or thumbnail sketching is that a thought is captured as a pure and raw idea, not as a stylistic solution. When you look back over several pages of miniature sketches, you'll begin to see things you didn't intend to do while you were sketching. More important, when someone else looks at these same sketches, that person adds a whole new point of view to your raw ideas. As more people look at the sketches, more ideas are created. This is because sketching is not a precise technique. It leaves room for interpretation.

Choose Tools That Implement Creativity

MEN HAVE BECOME THE TOOLS OF THEIR TOOLS.

Henry David Thoreau, writer

COMPUTERS ARE USELESS. THEY CAN ONLY GIVE YOU ANSWERS.

Pablo Picasso, artist

TECHNOLOGY IS A WAY OF ORGANIZING THE UNIVERSE

SO THAT MAN DOESN'T HAVE TO EXPERIENCE IT.

Max Frisch, author

The tools with which you sketch influence the interpretation and translation of thumbnail sketches. A sketch implemented with a pencil will have a different quality of line and therefore suggest different visual approaches than thumbnail sketches done with a brush. Sketching with color will suggest different interpretations than if you sketch in just black and white. Consider using some of the tools listed below while doing your sketching. Remember, doodling and sketching are supposed to be rough and raw—accidents are the source of many great ideas. There are certainly other techniques available to you; just find them and use them.

Pencil. Try sketching with a sharp pencil. Now a dull one. Try sketching with a soft one. Now a big pencil or a chiseled pencil. Your ideas will change as you change your pencil.

Brush. Few designers take advantage of the conventional painting and drawing tools from our training years. We forget how we think differently with a brush in our hands. Fluid strokes beget

interesting form. Liquid color always begets happy accidents.

Color media. A suggestion of color can change the spin on a sketch. In a finished piece of designed communication, broad strokes of color or spot color can change the emphasis, meaning and impact of the message. Color sketching will help you see these shifts early in the process.

Cut and paste. Remember the feeling you had when you were a kid creating with crude tools? Crayons, blunt-ended scissors, tape, white paste—we did anything we could to get what was in our head onto the piece of paper. Now there's a fresh idea.

We've discussed collecting materials that influence the way you think about the problem, as you see them, and storing these materials in a sketchbook, folder or binder (see pages 44–45). Now get them out and start cutting and pasting. Sketch through collage. Leave nothing intact. Cut it out or photocopy it and draw on it. Obviously, things will happen that are unexpected and accidental.

Dimensional sketching. Your choices of paper, format, materials and folds are all influenced by the content and, in turn, affect the concept. The feel, sound and smell of the sketch will enhance the concept.

Sketching on the computer. The computer is a unique sketching tool, when you let it be. It helps us see things in ways we couldn't see them before. When reviewing sketches implemented on the computer, print them out before evaluating them. Put these sketches beside pencil sketches. Rip and fold the computer sketches to isolate the ideas. Draw on the computer sketch. Don't mistake a sketch for a finished layout and treat it as sacred and unchangeable. Above all, don't present or evaluate the computer sketch on the computer screen. You eliminate a world (one that is outside of the computer) of influences that could impact that sketch by doing so.

Also remember that you may know you are sketching on the computer, but the client doesn't. When something *looks* finished, a client assumes it *is* finished. Once that happens, you may be forced to stop at the idea phase, long before you've found the best idea, or polished the one you just presented.

That's one reason why the computer is both blessing and curse rolled into one expensive tool. And that's just what it is: a tool. It is the pencil of the late twentieth century, nothing more. It is not the brain. It is not a designer, a photographer or an illustrator. Designers have a responsibility to do what we are paid to do—design. Although the computer can be a great tool for making visions reality, too many designers use it as their only tool or, worse, as a substitute for thinking. These designers use the computer as a sketching tool, thinking tool, writing tool, typesetting and illustration tool, and production tool. All this is well and good, until you can't tell where one starts and another ends. Then the tool has mastered the designer, not the other way around, and the designer may have begun abdicating his responsibility to the computer.

Sketching Out an Illustrative Style.

Warner Bros., Total Jazz CD Cover

Vittorio Costarella explains how Modern Dog developed a reputation for a highly illustrative and humorous approach to its design work. "It all started with our early clients and the work that resulted. We worked a lot with low-budget theaters. We couldn't afford photography, so we had to create our own images. And the illustrative approach grew from there."

Costarella gets much of his inspiration from sketching. "I keep a sketchbook, and most of the work comes from there. I'm always drawing. I used to carry the sketchbook everywhere; I never knew when the images would come out. But the price of our success (or at least of being busy) is being too tired to sketch when I finally get home at night." Among the sketches are many examples of hand-drawn type. "Most of the time, plain type is not enough. I want a more personal feel. My sketches include words, so it seems natural that the type and image become an extension of each other in my work."

The studio is full of other kinds of visual inspiration, too. "We have lots of books at the office. All of us 'thrift' a lot. We pick up old books, catalogs, magazines and old encyclopedias at the flea markets. The images in these old publications keep the brain active for hours. We have so much inspiration in the office that we're running out of space. It's a mess. Robyn (Raye, one of Costarella's partners) calls it 'the basement rec room' look. Clients really like coming here, however; they're really comfortable. And at least our meeting room is halfway presentable."

When asked how to stay creative, Costarella suggests, "Be yourself. Don't get watered down. Take a client for bread-and-butter if you have to, but retain your own unique approach and find the clients that let you do that. It takes time to build, but it's worth it. The more soul you put into your work, the more dynamic the result.

"We were given total creative freedom on this CD cover for Warner Bros. The artists were all modern-day jazz musicians doing classical jazz. I reached back to the 1940s and 1950s, the Blue Note (record label) era, for inspiration. The client approved my first layout but then called us back and said that the image was inappropriate. It had a negative spin to it. So I thought of the "cool cat" concept, and the cover was born. I use negative images, white on black, a lot because they seem to have more impact. I'll draw an image and then look at it in its negative form."

A Picture Is Worth a Thousand Words

The images used within the piece are just as important as the words. They can be used to support words or in lieu of words. Images can be created by you, by a photographer or by an illustrator. You can use existing images or have images created. Images, like words, can grow out of any of the creative seeds germinating from the brainstorming. Images can be simple, complex, diagrammatic, documentary, emotional, big or insignificant. Even no image—just a broad stroke of color, for example—can be interpreted as an image in the right context. But if the image doesn't reinforce the message or move the communication along, it's not worth the paper it's printed on.

They say that a picture is worth a thousand words. This is a good measure for evaluating the picture's effectiveness within a communication. If it replaces the need to say those thousand words, it does the job it was intended for. If you have many photos on a page, however, you may be trying to say too many things at once. Imagine six photos and six thousand words on a page, (one thousand words for each image). That's clearly too much information for one page.

Images are created using the same techniques we discussed earlier in this chapter. As you brainstorm, you will find it difficult to discern what part of a concept should be developed through words and what through image. Metaphor, opposites and puns can all be created through images as easily as through words. These decisions come out of your vision and approach.

Pictures, of course, come in many forms. We don't need to review those here; instead, we need to discuss how you can implement creativity more effectively by integrating image into the communication.

Let's start with the scenario that you are working with an illustrator or a photographer. Your basic decision on who you use and why is largely based on style. The visual style that the imagemaker uses is consistent with the message you are trying to communicate. How then do you work with this person to facilitate a creative result?

- Learn and understand the working style of the imagemaker. Some creative professionals work best when given total freedom. Some need a bit of direction to bring them closer to the message. Interview them, listen to how they talk about their work, and get a feel for their strengths and weaknesses.

- Integrate the imagemaker into the creative process as much as you have involved the writer. Respect the artist; the images are half of the piece. Your information will be beneficial to her, and her ideas can be woven into your product, thereby benefiting you.

- Budget and schedule for the involvement of imagemakers. Anticipate the need for images and budget for appropriate imagery. Too often, it's not until you're halfway into the project that you realize the need to purchase images. This is probably not the best time to tell the client you want to spend another $10,000 on pictures. Image creation also takes time. If you have planned to have pictures created, they can be created while another part of the project is taking place. With planning, you needn't add time to the schedule. But you must give the imagemakers enough time to do the job.

Of course, you can create or find your own pictures. (Some designers integrate image into their approach to design so much that you really can't tell what is design and what is image.) Images also can be supplied by the client. Wherever the images come from, whoever creates them, is really unimportant. What is important is that they are:

Dynamic (present an interesting point of view)

Smart (make your readers think)

Unique (make your readers see something in a way they don't normally see it)

Emotional (appeal to the human side of the audience)

Understandable (Help the readers understand the message through the image)

Appropriate (move the message forward with the image, don't distract the readers with the image)

Beyond Ideas

When Do You Stop Brainstorming?

You are never done brainstorming. The better question is, "When do you start translating ideas into design?" Brainstorming and conceptual development will continue throughout design development. Every time you make a decision regarding the project, you integrate brainwork. Every refinement to the design is the result of brainwork. Do not stop thinking about the project. Simply understand that you cannot rest until design is complete.

The Voice of Judgment

Before you form ideas into solutions and implement them, you reach a critical point in the creative process when you must commit to the ideas that you believe in. At this stage, you can present the client the very thing that you know he wants to see. Or you can present ideas that you know will work, even if these are not what the client wants. You can be bold and aggressive with your presentation, or you can be safe and neutral. Although you don't know it, you are fighting an unseen monster—something that eats at you and influences your decision making. Before you move onto the next part of the book, I want to introduce you to your nemesis, the voice of judgment (V.O.J.).

According to experts on the subject of creativity and psychology, the V.O.J. is that inner voice, driven by fear and guilt, that prevents you from pursuing creativity with the confidence that you have a really good idea. We all remember when we were kids in elementary school, and the teacher asked the class a question. All of us hid behind our desks or our books to avoid being called on, for fear that what we said would be wrong and we'd be laughed at.

This is the same force that prevents us from presenting a presumably risky idea to a somewhat conservative client. And when we do present a risky idea, it is presented against a "safe" idea so the client won't think that we have lost all of our marbles. Of course, the client chooses the safe idea, and you return to your office kicking yourself for not pushing the more creative approach or for presenting the safe idea to begin with. Knowing that the V.O.J. exists is the first step in dealing with it. The V.O.J. takes on several forms:

- The voice inside you that makes you fearful to pursue creativity and that depresses you when you don't. This is the hardest to overcome because we are our worst critic. Ironically, reason and logic work best to overcome a personal fear. The often-asked question, "What is the worst that can happen if I present this idea?" usually produces an

answer that is easy to deal with.

- The voices of others who have judged you unfairly; those voices in turn fuel the internal voice. These are the kind of people who get in the way of a good brainstorming session. Learning to ignore these voices is as important as squelching the internal voice.
- The voice of society that dictates etiquette, style and, in our case, "acceptable design approach." Designers are exceptionally victim to this voice. We often wait until a design trend emerges before we consider it to be valid. We let others set the standard, and we track the standard by reading our design journals and annuals.

The V.O.J. lives in all of us, including the great design mentors, Nobel Prize winners and politicians. Those who succeed at being creative and pursue their ideas and dreams have the ability and confidence to control their own V.O.J.

Forming Ideas Into Solutions

The ideas that have evolved through brainstorming will be fashioned into actual solutions through a process of editing and evaluation. Common design tools such as grids, typography, color and paper begin to come together as you implement the idea. We each have our own comfort level with these tools. Use them as you see fit. But never forget that these tools do not replace a basic concept. Far too many designers begin the design process by picking up their tools, without first brainstorming or settling on a concept. These designers are then simply styling, not adding substance to the communication, because they don't have a real idea beneath the surface.

In the next chapter, we will look at using conventional design tools in unconventional ways to sustain a level of surprise and innovation throughout the project. You must keep thinking, even while kerning type or juggling images on a grid, to make that happen. I believe that the decisions you make throughout that process must be intelligent ones evaluated against the communication objectives and the design criteria. They can't be decisions based on the latest style, trend or printing technique. They can't be based on your most recent viewing of the design annual in today's mail. They can't be based on a designer's, or a client's, need to create an imitation of today's hot designer. Successful creative design can only be driven by the needs of the client and the audience.

With that said, a designer should not be afraid to follow intuition. A painter does not overintellectualize while creating. An engineer or a researcher creates based on hunches and hypotheses. Intuition plays a big part in the development of an idea into a finished product. Follow your intuition while keeping one eye on objectives and the other eye on the idea, and your design decisions will be right on.

Creative Passion.

Posted Communications, Poster Series

Maria Grillo loves her work, pursuing creativity with confidence and enthusiasm. She's high-energy and responds to the same attitude in her clients. "I don't know what I'd do if I didn't enjoy this process." She's upset when she sees the work of designers who don't experience passion in their work. "It shows. You would do yourself, and your clients, a favor by moving on to something else if you don't love doing this. Design should move people. . . . Design is life. One of my professors in college showed us how to open up to all experiences. He showed us how to pay attention.

"A few years ago I went to hear Robert Greenberg speak. One statement he made really meant something to me: 'Design should not be a strictly two-

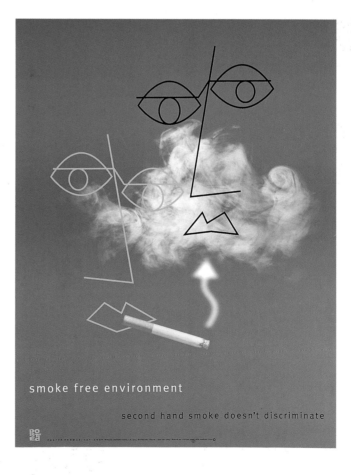

dimensional experience. It should reflect the passage of time. All design should have a beginning, a middle and an end.' I keep thinking about what this means. It inspires a depth and a dimension in my work."

Grillo's passion for design shines through this line of "message" posters for the office environment. Posted Communications asked Grillo, a partner with VSA Partners, to work with them on product development from the ground up while at the same time establishing an identity for the company. Developing a relationship with the client that opens the process to more creative, "riskier" solutions played a key role. "We've spent the last year and a half educating the client as to what we do. We've walked him through the creative process, step by painful step. He still questions the process and the budget, but he loves the work. He gets emotional when he sees something he really likes.

"We created two different product lines, both with the same messages and each appealing to a different sensitivity level in the audience. The "black series" is sophisticated—highly metaphorical and subtle—with slick photography so it will appeal to a thinking audience. The other direction, the "blue series," is a lighter approach, featuring these stylized characters reacting to the situation described in the message. Both series engage their audiences without perplexing them.

"I don't think we do creativity any differently than anyone else. We collect all the information and review it immediately. I think some people save the information, avoid cracking it open out of fear. You know, like a new dress, once you wear it, it's yours, you commit to it. Well, we wear the information a bit before we put ideas down. After the information sinks in, we talk about it in the group. We come to a consensus of what the message is and how to most effectively communicate it, without the trash and trinkets of design. We all participate in the generation of ideas, and we all have ownership. Ownership is motivation to designers. Unfortunately, we are all fighting that darn ego. But we have to get over it. We have to get over this idea that we have to be better than everybody else."

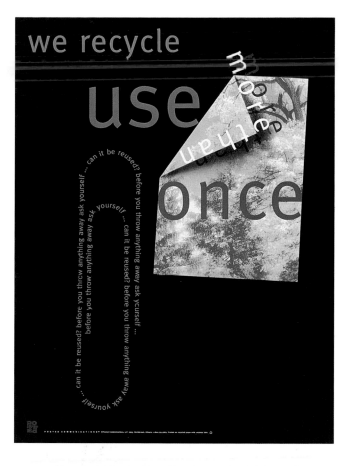

Growing Ideas

THE TEST OF A VOCATION IS THE LOVE OF THE DRUDGERY IT INVOLVES.

Logan Pearsall Smith, scholar

EVERYTHING MUST EVOLVE OR ELSE MUST PERISH.

John Knowles, author, A Separate Peace

The ideas are sitting on the table in front of you, queued up like soldiers waiting to charge into battle. Now what do you do? In this chapter we'll explore how to translate creativity into communication. We'll analyze the significance of risk, the impact of rationale, and the dynamics of relationships. We'll distinguish between the pitfall of design influenced by style and the success of design driven by objectives. We'll leap from the small details to the big picture. And we'll manage the process so the client begs for more.

Editing Ideas

Evaluating Your Ideas

Objective evaluation and fair judgment can be more difficult than actually developing the ideas, particularly when they're your ideas. How do you know if an idea will get off the ground? Will it crash-land on the client's desk? Will it fly right over the client's head? Will the idea fly far enough to even reach the audience? If it reaches that destination, will it have a safe or disastrous landing?

Judging ideas, especially your own, requires balance between realism and creativity. Being realistic keeps the most bizarre, unreadable and uninterpretable ideas from being produced. Realism reminds us of the objectives of the project and forces us to accept constraints such as readability and budget. And being realistic helps us work with uneducated and unrealistic clients in evaluating our great design ideas.

balancing

Being creative, on the other hand, means balancing on the edge, pushing harder, taking risks, and staying new and fresh. Being creative helps your message stand apart from all the other communications surrounding it.

pushing

You must embrace both realism and creativity throughout the evaluation process. Being too creative can cause you to lose sight of the communication objectives for the project. Being too realistic can blind you to risky, innovative solutions.

Reviewing the Objectives

WE CREATE SOLUTIONS IN RESPONSE TO PROBLEMS. THE MORE SPECIFIC THE DEFINITION
OF THE PROBLEM, THE MORE DIRECTED THE EFFORTS AT SOLVING IT. CONSTRAINTS ARE
NOT YOUR ENEMY, BUT YOUR FRIEND.
Rick Eiber, Rick Eiber Design

The obvious first step in the evaluation process is to reacquaint yourself with the communication objectives that were established and approved by the client at the beginning of the project. Those objectives define the audience, the message, the environment and the delivery. A successful idea will

easily meet the communication demands set by these definitions.

Communication objectives take on a different meaning after you've had a chance to think about the project and work through a concept development phase. They can now be viewed relative to your concept work. Because your ideas evolved from these objectives, many of them will fit the objectives perfectly. But because the brainstorming process leads you down unforeseen paths, some of your ideas will bear no resemblance to the original problem. It is up to you to objectively, logically and systematically find those ideas that are in line with the objectives.

Discuss the objectives with an impartial group of colleagues that acts as a sounding board for evaluating and editing ideas. When discussing the ideas with people who have not been involved in creative development, you must articulate your thought processes and explain assumptions made during your brainstorming. People not exposed to the information prior to the editing session provide a fresh point of view. They should challenge inappropriate assumptions and unclear concepts. The group should also expand on ideas, collectively growing each valuable idea into a completely fleshed-out application of a creative concept. Talking the concepts through, rather than simply sketching the application, guarantees that the words and images grow together equally.

Remembering the Design Criteria

Obviously the design criteria dictates how the concept is played out on a production level. You must now embrace the criteria discussed and documented at the beginning of the process. Define all constraints and prepare to stay within them. Factors such as budget and schedule dictate the scale and scope. Mailing and delivery criteria can dictate format and size. A client's desire to use recycled paper, corporate colors or identity standards all affect the evolution and development of the ideas.

PARAMETERS SUCH AS THE DESIGN CRITERIA DICTATED BY THE CLIENT, PRINTER OR AUDIENCE NEED NOT LIMIT CREATIVE FREEDOM. IT'S MORE APPROPRIATE TO VIEW THEM AS A FRAMEWORK WITHIN WHICH WE ARE FREE TO TAKE RISKS.

Parameters such as the design criteria dictated by the client, printer or audience need not limit creative freedom. It's more appropriate to view them as a framework within which we are free to take risks. What should matter is that you are aware of all these constraints right from the beginning. Designers view clients as unreasonable only if these parameters are introduced midstream in the project. And clients view designers as inflexible if they resist such demands. If you work with the client from the beginning to set and understand these limitations, there will be no surprises.

Constraints as Creative Opportunity

1993 Jacor, Inc., Annual Report

"There were three things that inspired the direction we took on this annual report," says Robert Petrick of Petrick Design. "The positive energy we felt from the client, the unique character of the new CEO, and the low-budget and six-week schedule. Brainstorming started with a review of the radio industry and the company's history, position, and plan for the future. Subsequently we began a group exploration of radio words, radio formats, impressions of radio, and the relationship of radio to other media." After the group work, Petrick and the lead designer, Laura Ress, edited the ideas and sketched.

Due to the tight schedule, thumbnails were presented to some key decision makers to quickly focus the design effort on the strongest concept. The CEO's letter became the driving force for the inside of the book, with a simple, loud, bold, in-your-face graphic style. After Petrick came up with the "Radio Active" cover concept (while on hold during an interview with a radio station's program director), he faxed the idea to the client to facilitate quick discussion and approval. "The phrase has a wonderful double meaning. We avoid the deadly

Listen,
1993 was a great, active year for Jacor. We made a few smart decisions, hired some great people, reduced our debt to zero, increased our access to capital, and built share in all of our major markets. Some companies might see those steps as final objectives. But we see them as a new beginning.

Jacor is a "new" company, with new leadership, a new ownership structure, and a highly focused resolve to take full advantage of a

for Jacor to be active in continuing to merge, consolidate and concentrate strength within markets.

The financial strength and flexibility we now have as a result of our public offering last fall gives us the chance to go after acquisitions of individual stations or smaller groups—or even to go for a larger portfolio of stations when it makes sense.

The opportunity to own, operate and represent multiple stations in a given market gives us a chance to pull together

sports programming, news/talk, attention grabbing personalities, visible and sometimes unorthodox promotions. But we don't approach anything with a formula. Except that we want the highest-quality delivery systems—the best signals available—in each market, regardless of whether they're AM or FM.

Radio's business is to move product or services for advertisers. Jacor's business is to create unique station identities that build listener loyalty, and cement long-term viability.

Rush Limbaugh

connotation by keeping it as two words, not one. Active becomes a key message.

"I explained the idea in a one-page summary. The best design should be presented in words only, well articulated, precise and succinct. This demonstrates strategic thinking and accurate understanding, with an emphasis on the concept, before the focus becomes style. Your client is forced to agree or disagree with the concept at this point and, if they agree, everything that follows is just style and opinion. If they trust your sense of style and aesthetic judgment, you should end up with good design."

With only six weeks to design and produce an annual report, the design team had to think through details in advance, make decisions quickly and stay flexible. They found it a stimulating process. Cost-cutting measures became creative opportunities. "No money was spent on photography because we used publicity stills of radio personalities. Fluorescent inks and a large dot pattern disguised the inconsistent photo quality and reinforced the 'radio active' concept. Our print specs included a press test of fluorescent inks, multiple line screens, and a variety of stripping methods. This way the designer was able to manage budgetary expectations with the client while integrating a bit of experimentation into the manufacturing process."

Clients generally embrace objectives, constraints and criteria that they helped to create. These factors influence your design and, if they're discussed and approved with the client's help, they'll remain intact throughout the process. These factors can (and often do) change if decision makers change—if, for example, your client is not the real decision maker. When such a change occurs and it appears the original objectives and constraints are forgotten, return with a previously agreed-upon list of objectives. (An approved, written proposal that clearly spells out objectives and the related costs of working within the constraints and criteria is an excellent record of what was agreed and why.)

Editing: Transforming the Concept

ALMOST ALL MEN... HAVE STRANGE IMAGININGS. THE STRONGEST OF THESE IS A BELIEF THAT THEY CAN PROGRESS ONLY BY IMPROVEMENT. THOSE WHO UNDERSTAND WILL REALIZE THAT WE ARE MUCH MORE IN NEED OF STRIPPING OFF THAN ADDING ON.

Doris Lessing, writer

NOTHING IS EVER SO PRECIOUS THAT IT CAN'T BE EDITED.

Clement Mok, Clement Mok designs, Inc.

Spread your ideas on the table. Gather your colleagues. Put a sketchpad in front of you. Close the door and grab a pencil. Your ideas still take many forms at this point. They have been collected in sketchpads, sketchbooks, notebooks, a file, a folder, or on loose scraps of paper. You might have photos, items ripped from magazines, type samples and color studies. Everything should be in front of you and open for editing, translating and transforming into designed communication.

"Editing" implies that you are only *eliminating* ideas that are not valid. But that's only one part of the editing process. More important, you are looking at the raw ideas and objectively evaluating them, discussing them, expressing the rationale behind them, and retrofitting them into the objectives. You are translating and transforming your ideas into a more appropriate form. There is an intuitive process that takes place. Some of the ideas speak immediately to you. Others do not. Talk about the ideas, verbalize the concepts and, as a group, push the ideas.

Pushing ideas is more than visualizing the finished piece. A sketch is a mental note to remind you of a full-scale concept or thought. What you intended by that sketch may not be what someone else reads into it. When you discuss the interpretation of that sketch, you are pushing the idea behind it. Discussing an idea involves testing it and expanding on it from the reaction of others. Note progress that occurs during the discussion. Your thinking will always move forward with a

"pushing interaction." If the idea doesn't grow, it probably should be discarded.

Editing transforms the concept. The process pares it down to the bare essentials for communication. Too often, clients and designers attempt to cover all the bases by throwing a lot of information, photos, graphics, icons, borders and rules into the communication. If the audience doesn't get the information one way, they reason, they'll get it another. Instead of encouraging the audience to understand, however, you'll discourage them from reading altogether. Make it easy for the reader to find, understand and respond to the message.

WE START WITH THE READER'S REACTION AND DESIGN BACKWARDS.

John Coy, Coy Los Angeles

To successfully transform concept into communication, solicit three reactions from the readers:

1. *"Aha."* The reaction of discovery must come from a reader's first look at the message. The "aha" factor solicits an investment of time and mental energy in deciphering the meaning of the communication. If readers are intrigued by and want to be involved with the concept, you've achieved a high "aha" factor. If they're too bored or challenged, they'll lose interest, and you will have achieved a low "aha" factor. The faster the readers say "aha," the better.

2. *"Got it."* If the readers are intrigued and involved, they move beneath the surface to get to the essence of the communication. The ability to skim the information and glean the most important points will keep them hooked. On the other hand, if readers need to invest a lot of time to get more information, you'll lose them. That's a low "got it" score. Keep the information accessible and skimmable. Interesting headlines and images and highlighted bits of information that reinforce the message score high on the "got it" scale.

3. *"More."* You want to leave the readers wanting more. After they've skimmed the communication, they hang around a bit longer to actually read it in detail. When the readers finish, they respond in the manner you chose—you elicit the response the client wants. Raise your "more" score by filling the communication with just enough well-presented information. Don't forget to tell the readers what you want them to do when they've finished with the communication.

These three factors—enticing readers with a great teaser, drawing them from an effortless skimming to careful examination, and creating an appropriate, pleasing implementation—will transform the most intangible concept into an effective communication.

Editing: Eliminating

QUALITY GIVES EXPERIENCE. FOR THROUGH EXPERIENCE ALONE CAN QUALITY COME.
ALL ARTS, BIG AND SMALL, ARE THE ELIMINATION OF WASTED MOTION IN FAVOR OF THE
CONCISE DECLARATION. THE ARTIST LEARNS WHAT TO LEAVE OUT.

Ray Bradbury, author Zen in the Art of Writing

THE DEFINITION OF A "GOOD" DESIGNER IS SOMEONE WHO KNOWS WHAT TO KEEP AND
WHAT TO THROW AWAY. THIS APPLIES TO EVERY ASPECT OF A PROJECT—FROM INPUT,
IDEAS, AND CHOICE OF MEDIA TO WHAT GETS PRESENTED.

Rick Eiber, Rick Eiber Design

Be ruthless. You can never be too discriminating when eliminating ideas. The point of this process is to present to your client only the best ideas. If you've done a good job of brainstorming, you should have pages and pages of ideas to work with. Many of them are great ideas; many aren't. Weighing one idea against another will help you determine which ideas work best.

KNOWING THAT A CLIENT WILL INSTINCTIVELY PICK THE ONE OPTION YOU DO
NOT STRONGLY SUPPORT SHOULD MOTIVATE YOU TO PRESENT ONLY THOSE IDEAS
YOU BELIEVE *WILL* WORK.

Brainstorming produces a lot of ideas, and you shouldn't throw any away during the creation process. But during editing and evaluation, you must become an objective judge. How do you get rid of ideas that only *seem* to be appropriate? The best incentive I've discovered is setting a limit of only three possibilities for presentation to the client. Knowing that a client will instinctively pick the one option you do not strongly support should motivate you to present only those ideas you believe *will* work.

Showing many ideas might give the client the impression that you worked hard and are committed to the project. On the other hand, presenting too many ideas is counterproductive to the goal of choosing a truly creative and appropriate approach. The rationale for presenting no more than three ideas—sometimes only one or two if you feel strongly about them—is that clients are overwhelmed by quantity. It's more difficult for them than it is for you to decide among many ideas. If you can't narrow the options, how can you expect a client to do it for you? When presented with too many ideas to choose from, clients develop bad habits:

They mix and match pieces of different ideas rather than choose one well-conceived idea.

- They can be so overwhelmed that they want to hold onto the presentation to deliberate without you in the room. In your absence, they deliberate without your insight. They ask the opinions of others who aren't involved in the process, getting uninformed input that can derail the process.
- They develop the expectation that they will see ten ideas every time they hire you to design a project.

So remember the consequences, and don't force the client to do your job for you. Only show your best efforts. Leave lesser ideas at the office.

To show only your best ideas, you must eliminate others, even ones you truly like. Keeping in mind that you will present no more than the three best directions forces you to be more critical. The process in our studio is a simple one: We present ideas one by one and then review them together. A group discussion brings out the inherent strengths and weaknesses of each idea.

Eliminate ideas only for the right reasons:

- If any aspect of the idea does not work. Even the smallest part of an idea can get in the way of successful communication.
- If an idea is built entirely from style and technique.
- If an idea isn't clear or won't be understood by the identified reader.
- If an idea doesn't solicit any reaction from anyone in the group. (It is clearly not exciting.)

Don't eliminate ideas for the wrong reasons:

- If an idea is offensive or disturbing. This is not necessarily bad. Remember it is soliciting a reaction, an objective for all design. You may need to soften the message or spin it in a different direction. Reaction, any reaction, signals good communication.
- If an idea is good but surrounded with distracting style and technique. Eliminate the style. Extract the idea, and rework it to bring out the concept.

MAN FIXES SOME WONDERFUL ERECTION OF HIS OWN BETWEEN HIMSELF AND THE WILD
CHAOS, AND GRADUALLY GOES BLEACHED AND STIFLED UNDER HIS PARASOL. THEN
COMES A POET, AND ENEMY OF CONVENTION, AND MAKES A SLIT IN THE UMBRELLA; AND
LO! THE GLIMPSE OF CHAOS IS A VISION, A WINDOW TO THE SUN.

D.H. Lawrence, writer

Combining Ideas

Passport Brochure

Closer Look Video Group asked Mark Oldach Design to develop a brochure to solicit funding for the production of a TV broadcast series. It would feature a host traveling the world, exploring cultures and people, art, music, language and politics. A high-energy series targeted for a young audience, "Passport" is more than a documentary. It mixes information with entertainment through its emphasis on humor and beauty.

We combined two ideas—the compass as a symbol of travel and the character of the video medium in print—in developing the design of the brochure. The compass inspired the cover and, believe it or not, the grid used throughout the brochure. The brochure is structured by a strict quadrant division of each spread, reminiscent of the four points of the compass. These same compass points define the series content on the cover.

The video textures and TV-inspired typographic play inside translate the character of the video medium onto the printed page. Note that the type jumps from top to bottom on one spread, and look at the "closed caption" style text line running at the top of each page.

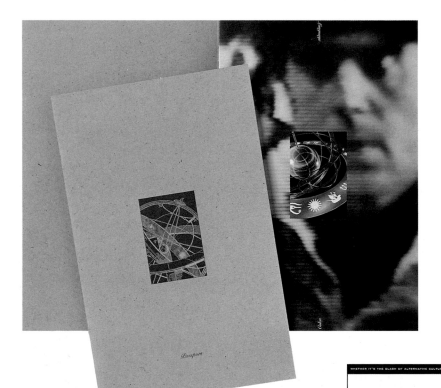

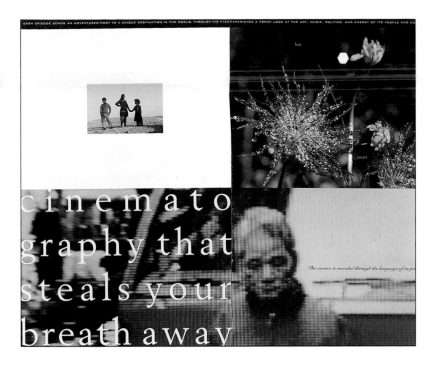

We also rephotographed some video footage from a TV screen and further enlarged it to exaggerate the scan lines of video. These video images add the texture of the medium to the brochure.

Creating this brochure was a lot like painting using contrasting elements as the paint. The rough video images contrast with high-quality still photography, both shot during a trip around the world to capture sample images. A serif typeface contrasts with a script typeface and a square sans serif face. Large type and images are set against small ones; flat graphics against dimensional, colorful photography; and rough, uncoated paper against slick, glossy paper.

In fact, the brochure grew like a painting with the overlying messages guiding our brushstrokes. Photocopied images, laser-printed type and images on overlays were cut and pasted into layout sketches. Working from a rough sketch, we sat at a table with scissors and tape, arranging the elements, balancing one image with another. We fit the pieces of four spreads together like the pieces of a jigsaw puzzle. Design, writing and execution occurred simultaneously. Since there was no time for a formal approval process, we made decisions together in one room with the client. This creative process would never have worked if it hadn't been driven by a strong message drawn from a clear understanding of the objectives and based on great trust developed between client and designer.

Design Concept vs. Design Refinement. Now that you've whittled your pile of ideas down to no more than the three best, the elimination process continues in the client presentation. All designers have different approaches to managing creativity with clients. I have had the most success getting clients to make intelligent decisions relative to creativity when they've been involved in the process. To facilitate that involvement, I break the design process into two stages: design concept and design refinement.

The design concept stage can be anything. I try to show a variety of ideas in raw form through penciled thumbnails or miniature cut-and-pasted sketches, but only those that are creative and appropriate. I usually present ideas in black and white to focus decisions on the concept rather than the color or quality of a picture. I draw the client's attention away from the typography by presenting the same concept in a variety of typefaces. Illustrators' and photographers' tear sheets, color swatches and scraps of paper are also included in the presentation. Raw sketches and computer layouts are presented, but none of the ideas are, or look like, comprehensive layouts. I find that presenting ideas in rough form brings the client closer to the thought process behind the idea.

I ask that only one concept be approved by the end of our discussion. I'll come back for further discussions if necessary. But we won't proceed until a single concept is chosen and a clear direction has been determined. I've found this approach works best if I'm always present during discussions—all discussions—about the ideas. So I don't relinquish the presentation to the client, thereby dictating that I am present for all discussions. Sometimes I can avoid leaving the presentation, sometimes I can't. I do find, however, that I can usually keep the presentation if I establish that procedure at the beginning of the project. That way, the client doesn't expect to keep the materials and discuss them in my absence. (For more on managing client expectations see pages 17–18.)

The design refinement stage gives the opportunity to translate the agreed-upon idea into a finished layout. In my design firm, the designers take the essence of the idea that was discussed and approved and explore variations that fit the design criteria. Color(s), typeface, paper, size, binding and folding are all considered and become an extension of the idea. We may or may not present layout variations. The idea presented may be very similar to that of the concept presentation or it may be completely different, depending on what was last discussed with the client. Even if it's completely different, the idea presented after design refinement still can't surprise the client. The refined idea should appear as an evolution or outgrowth of the earlier idea and lie well within the boundaries of the project's objectives and previous discussions with the client.

I strongly believe this two-stage presentation process helps clients make appropriate decisions, involves them in the thinking process, and provides them with choices (an appropriately limited number), but still keeps the creative control in my hands.

Adding Substance to Concept

IMAGINING THE PHYSICALITY OF THE PIECE IS NOT THINKING ABOUT WHAT IT LOOKS
LIKE. PHYSICALITY GROWS WITH THE WORDS AND THE PICTURES.

Todd Lief, writer

Voice, Vision and Viewpoint

Ideas that fall in line with the objectives will also need to be evaluated against their ability to stand out against the onslaught of communications in our environment. Communication has evolved into a sophisticated, competitive, noisy and overwhelming universe. Your audiences watch movies with sophisticated graphics and sound. Weather reports in the newspaper look like animated cartoons with charts for characters. Music blends influences from every culture in the world into harmonies; it's even manufactured by computers. Voice mail, faxes and satellites dominate our daily professional and personal communication. And no one can distinguish between real and digitized video and sound images.

This noisy environment affects our audiences, the mass market of consumers. Data compilers tell us that the average American reads at only an eighth-grade level. Most Americans watch TV during more than one-half of their waking hours. Our audiences expect to get information through entertainment. People are rushed, lazy, tired and easily bored.

How, then, do you reach the unique group of people that has been identified by the client as the audience for this particular piece? How does your message stand apart from other communications in its crowded environment? How do you compete with all the visual and verbal noise out there? Voice, vision and viewpoint. Your communication must:

- Speak with a single, distinctive voice.
- Project a focused vision.
- Present a unique viewpoint.

Let's look at these one at a time.

Speak With a Single, Distinctive Voice. If you walk into a room where everyone is talking at once, it's difficult to distinguish one conversation or statement from another. You might hear snatches of dialogue, but you won't get the whole interaction. If all the people talked directly to you at the same time, you wouldn't understand. But if only one of these people spoke, you would not only

hear her words, you would also see how she was dressed, observe her body language, follow the inflections and nuances of her voice. You could then respond to what she said.

So goes communication in print, especially when your client is a committee of people, each with a personal agenda. You, the designer, also have an agenda. There is a good chance that you'll produce a muddled communication if you try to incorporate everyone's voice. On the other hand, if you concentrate on blending those voices and yours into unison, the piece will speak with one voice. You'll then better hear the unique voice of the target audience and speak, one voice to another, with that audience. If you define a single voice and communicate only with that voice, your audience will leave with a better understanding of who is presenting the message. If that voice is also empathetic with the audience's point of view, they will pay even greater attention.

Defining a voice for your communication is like profiling a person. You identify a unique personality—its character, morals, ethics, politics, lifestyle, belief system and appearance—that will draw the target audience. Make that personality consistent throughout the entire communication. And make sure that voice makes sense, that its speech is directed by established communication goals. Then give it life through appropriate type, image, layout, structure, paper, size, etc.

Project a Focused Vision. You are sitting in a movie theater and the image on the screen goes out of focus. Here you just paid seven dollars, you're expecting to be entertained, and the screen is fuzzy. The screen gets fuzzier and fuzzier, until you can barely discern one character from another. You must guess who is talking, where the actors are standing, what they are holding, and so on. You get frustrated and leave. ("I want my money back!") The same goes for design. Communication lacks focus and gets fuzzy when you:

- Try to communicate too many things at once.
- Try to combine numerous ideas or conceptual approaches with no connection to each other.
- Try to soft sell the message. In an effort not to offend anyone, you don't communicate at all.

Follow these guidelines to create focused communication:

- Define a hierarchy of information. Tell readers clearly what you want them to read first, second and third. ("And if you have time, read this information, too.")
- Define the single message you want your audience to walk away with and forget everything else. Don't throw a lot of random information at the readers, hoping they catch some of it. Make it one message for one audience from one source.
- Communicate with conviction. If you know or believe something, communicate it. Share

focused vision

your client's faith in and enthusiasm for his product or service. (I design for Caterpillar's heavy equipment division, and I do get excited about the products.) Yes, you must be sensitive to others, especially your audience, but you can be so quiet and polite that you get run over.

If you communicate with a clear, focused vision, eliminating stray ideas or extraneous concepts, your message will always be understood.

Present a Unique Viewpoint. Changing the point of view encourages you to look at things in a different way. Take a message emanating from a corporation. Now deliver that same message from the point of view of a six-year-old girl, a seventy-six-year-old grandfather, a forty-six-year-old carnival barker, and a twenty-six-year-old garage mechanic. The message looks and sounds differently in the eyes of each of these people and will be interpreted differently by the audience. This is a basic concept but effective in presenting your message in a different light.

The point of view doesn't have to be human, either. It can be an animal, a thing, even color. Your audience is used to seeing a red stop sign. What if it's presented in purple? Your audience normally reads a word from left to right. What if it's written backwards? What if the standard message has an 8½-by-11-inch format, and you mail them something that is 2 inches square? The list goes on. The idea is not to make things different for the sake of making them different. The idea is to choose a point of view based on the objectives. Ask yourself if you want a voice that will:

- Capture attention?
- Entice the audience to read or to read more thoroughly?
- Facilitate understanding and meaning?
- Force the audience to see the same old thing with a fresh new face?

A change in point of view can force the audience to see the "same old thing" from a fresh perspective. One of my clients asked me to work with its staff photographer to develop images for a quarterly in-house newsletter. This person was an expert at producing "shake and smile" shots at ceremonies for public relations use. But our job was to document the delivery of significant services to a skeptical internal audience unimpressed by what it saw daily. At first the photographer wanted to shoot from eye level, straight on to most of the subjects. I directed him to move the camera away from eye level instead. This simple action changed the visual information from what the audience saw every day, making it interesting because it came from a different, unique point of view.

Apply the same principle to all aspects of design. Often readers have been conditioned to expect to receive information in the same way and format. When they receive information in a fresh,

change the way you look at things.

Form Follows Function

Museum of Contemporary Art Giant Book

"We wanted to invite Chinese, Mexicans, Japanese, Koreans and, of course, English-speaking visitors into the museum. We needed a way to interact with the surrounding multicultural community about the significance of art. We needed to talk to individuals about things like: What does a doughnut have to do with art? Why is geometry art? What does a Coca-Cola painting have to do with art?" says James Miho, the designer of the Los Angeles Museum of Contemporary Art's "giant book."

"Working with the education director at the museum was pretty straightforward because he tells it like it is. He described the problems and outlined the issues. Then the form was up to me. We wanted an inviting and intriguing form of communication that would speak to many cultures. Books are a common thread that connects many cultures. The function defined the form immediately. A bulletin board. A book. A giant book."

The freestanding installation would be located in the plaza outside the museum. The museum staff selected the questions and issues they wanted to feature

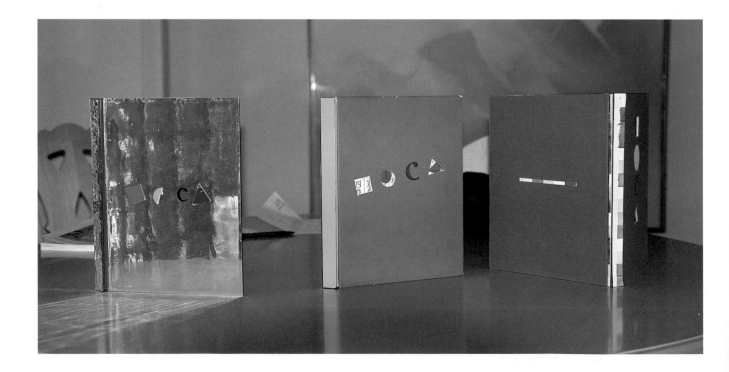

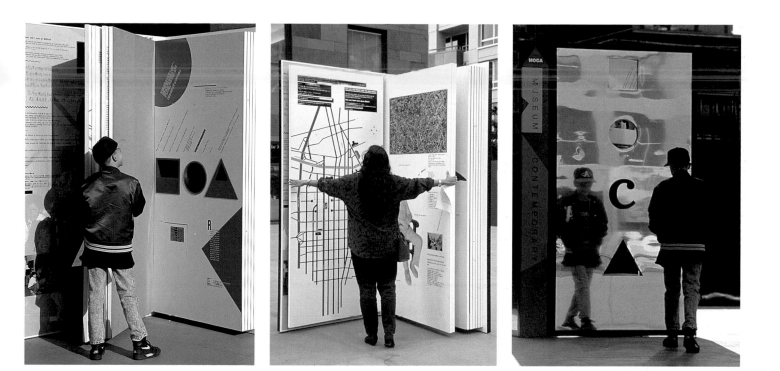

in the giant book. Then appropriate visuals were selected. "There is no interpretation of modern art in Asia, so we needed to describe the concepts in other ways, largely through art. This required the assistance of historians."

Translation of the copy into different languages was the difficult part. There weren't a lot of words because most of the information was visual, but the words did need to be correct and in appropriate dialects. Is Chinese best represented by Cantonese or Mandarin? Should Castilian, Mexican, or Central or South American Spanish be used? Because the same word in a different language may occupy more or less space when typeset, all translations had to be made before the layout could be completed. "I used several linguistic experts at the university. For Korean I worked with a graduate student from Seoul who understood art as an artist and who understood English. For Chinese I used a professor who understood Cantonese, Mandarin and English."

The result of the creative and creation process is a wonderful multicultural invitation into the museum. Words from many languages and images from many cultures merge within a common form of communication—a book, a very large book.

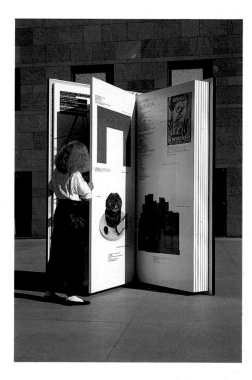

new way, they stop and take notice—even if the information itself isn't new. Take your choice of media, for instance. If readers are used to receiving a quarterly mailing that always looks the same and says much the same thing, they will more than likely ignore yet another such mailing. Take that same message and transport it via fax or video, and they will be more inclined to dedicate the time to the message. You've changed the way they see the message, so it looks new.

To show the audience something new, get into their heads and anticipate what they will think when they read your message. If you smile at the message while standing in their shoes, they probably will, too. Be honest when doing this exercise. If you claim to be standing in your audience's shoes but really project your tastes onto them, you will undermine your design and your client's objectives.

Risk Is Relative

RISK DOES NOT HAVE TO COME ACROSS IN THE OBVIOUS FORM.
IT DOESN'T HAVE TO BE NEGATIVE OR OVERLY EMOTIONAL.
IT CAN BE IN THE FORM OF THE SURPRISE, BY NOT BEING OBVIOUS.
Dana Arnett, VSA Partners

Most creative professionals say that creativity and innovation are only possible through risk-taking. Risk suggests that you step outside the boundaries of what is considered to be safe and predictable. In a sense, this is true. Most clients have a comfort zone where the predictable and expected solutions reside. The zone has room only for solutions that won't complicate the lives of the client or the client's boss. I rarely stay within that zone, so from that point of view, I do take risks.

But at the same time, I firmly believe that I do not take risks. Why? I don't present any solution to a client that I believe puts the success of the communication at risk. None of the approaches I present threatens the client or her future with the company. I present only solutions that are wholly appropriate to the problem at hand. I believe the audience will react to these solutions in the desired manner. In many cases, the audience's reaction will even exceed expectations because the solutions are not predictable. Therefore, I take no risks with any of these solutions. But compare these solutions to the guaranteed, safe or expected, and you might say my solutions are risky.

Instead of thinking about risk-taking, think about building trust. If you refine the message to its purest form, it will be strong and have great impact. The audience will definitely read and react to that message. It takes a dynamic designer to present solutions that elicit strong reactions. Encourage a client to commit to a strong, pure, substantive message. It takes a committed client to

risk monster

believe in and champion that message through the approval process. When you arm the client with solid rationale, good creative thinking and exquisite implementation, no one takes risks. This is trust.

Identifying an Original Idea

> A HUNCH IS CREATIVITY TRYING TO TELL YOU SOMETHING.
>
> *Frank Capra, film director*

> A ROCK PILE CEASES TO BE A ROCK PILE THE MOMENT A SINGLE MAN CONTEMPLATES IT,
>
> BEARING WITHIN HIM THE IMAGE OF A CATHEDRAL.
>
> *Antoine de Saint-Exupéry, novelist, essayist, aviator*

Is anything new? The answer to that question depends on how you approach design and the evolution of an idea. When you look in the annuals at what is being presented as the best of design, the answer seems to be "No." It looks as if every possible variation of any technique or style has already been implemented in the service of good, creative design. If you skim through design publications from the last twenty years, you might observe that trends, styles and techniques run in cycles. What is new and different today was old and passé twenty years ago. If you look at design from the angle of style and technique, everything has been done already. The only technique left to embrace is no design at all. (Even that has been attempted to an extreme with the advent of deconstructed type.)

However, if you approach design with the attitude that content, context and objective drive the development and implementation of all ideas, everything is new. Each unique problem begets—or should beget—a new and unique solution. Design is much more than style, it is a combination of message and packaging driven by a single objective. Style is a part of the packaging, but it doesn't drive the message.

IF YOU APPROACH DESIGN WITH THE ATTITUDE THAT CONTENT, CONTEXT AND
OBJECTIVE DRIVE THE DEVELOPMENT AND IMPLEMENTATION OF ALL IDEAS,
EVERYTHING IS NEW.

Understanding Style

Style With Rationale

Style is part of design. All creative professionals—architects, fashion designers, writers, gardeners—must address the role of style as it relates to purpose. Form vs. function. Each of us must determine, at some critical point in our careers, where on the form/function scale our work will fall. Some insist that style is everything. Others insist that purpose is everything. But many of us fall somewhere in the middle, trying to make the beautiful workable and the practical attractive. Communications design requires a delicate balance of reason, style, purpose and form. As you move toward either end of the form/function scale, there is an impact, an effect on your work. If you are too high on the stylistic end of the scale, your communication design will tend to be:

- Trendy and short-lived.
- High in visibility but short in predictable results and understanding.
- Appealing to a small, select audience.

All of the above can be good, if these characteristics are part of your communication objectives. If your work is too functional, your approaches will tend to be:

- Straightforward and direct.
- Generic and static in approach.
- Predictable and therefore inherently less interesting.

This, too, can be good—if it is what the audience needs.

I believe you can be creative and functional, practical and stylistic. *But you need to be appropriate.* The decisions need to be considered, and style must be supported with rationale. Any communication will be most effective if it's timeless. Advertising by nature is driven by style. But some of the most memorable campaigns in advertising history are those that don't rely on trends, such as the Volkswagen campaign in the sixties and *Rolling Stone*'s "perception/reality" campaign in the eighties.

It's dangerous for us, as a profession, to present ourselves solely as stylists. This encourages clients to view us as decorators, robbing us of the opportunity to add substance, analysis and thinking to their communications. These clients do a disservice to the potential for their communications and messages. They underestimate their audiences. They're also more likely to make decisions about design based on subjective criteria such as taste and opinion rather than on objective

criteria such as goals and strategy.

Creativity is not style. It's not technique. Style and technique are creative tools, but they're not the substance that sets a communication apart or demands that an audience react. The best communication, the best design, is that which breaks through the barriers of time or trend.

Passion as a Creative Tool

INSPIRATION COMES FROM THE THINGS THAT MOVE YOU.
Maria Grillo, VSA Partners

I can't imagine myself as a factory worker, a waiter or a car salesman. I don't believe any of these professions are bad or boring, because they aren't. Each requires a certain level of creativity in the performance of a skill or service. I simply have no passion for the tasks each must perform, and I get the motivation for my work from the passion I feel while creating it.

Passion is gut, instinct, rage and ecstasy. It is the "high five" moment when you produce a project that the client embraces, the audience reacts to, and you are proud of. Passion drives the search for the perfect solution to a problem. The solution is always there, you just need to find it. Passion finds it, sees it and knows it. Passion is addictive. Passion is a language that can be read in your work. It communicates with clients. If you feel passion, your work will reflect it, and the client will see it. Passion drives both good business decision making and outrageous creative thinking.

PASSION IS A LANGUAGE THAT CAN BE READ IN YOUR WORK. IT COMMUNICATES
WITH CLIENTS. IF YOU FEEL PASSION, YOUR WORK WILL REFLECT IT, AND THE
CLIENT WILL SEE IT.

Creativity is a product of passion. If you know it and feel it, doing it is easy. On the other hand, if you treat the process of design as a task and the product of design as a commodity, you might as well turn out nuts and bolts on an assembly line. The designer who accepts a job to design a brochure and mindlessly churns out another 4-by-9-inch, two-color, 10/12 flush left, rag right Helvetica brochure can't be enjoying his work. He is simply creating another piece of junk mail. The designer who can question convention, purpose and objective and then integrate that thinking into an intimate interaction between client and audience loves and feels passionately about design.

Style Inspires Content as Well as Style

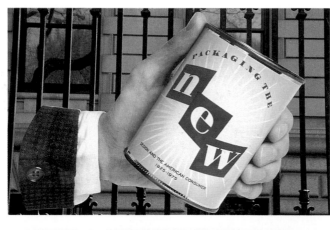

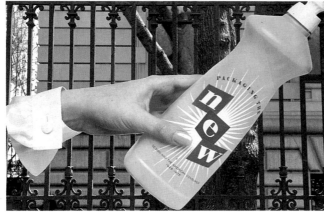

Cooper-Hewitt Museum Exhibit, Packaging the New

"Here we were trying to develop a conceptual approach for an exhibit that traces fifty years of style. How do you choose a representative style?" asks Alexander Isley of Alexander Isley Design. His reasoning may surprise you. "The 1950s and 1960s were characterized by a wave of consumerism that seemed to capture the spirit of the exhibit. Peanut butter and shampoo packaging are the main source of inspiration for the logo. Really, that's the inspiration for the concept. The graphics from packaging of that time period served as a model for the look and identity of the exhibit. It's an appealing and fun approach for the exhibit audience, and appropriate for the subject matter."

The scope of the project included the graphics for the exhibit itself as well as the identity, promotion and signage. For the fence signage, Isley used very large hands that seemed to pop from a 1950s ad holding a dimensional package. Each package featured the exhibit identity. The exhibit entrance featured a stack of cereal boxes silkscreened with the same identity. These were immediate ways to signal to visitors what the exhibit is about—packaging and consumerism. In this case, content and style are one and the same.

The role of style in design concerns Isley. "A lot of people say that our design firm has a style. I like to say that it might be characterized by an exuberance, a spirit. There's an emotion involved in our work. I can't design something I don't believe in. The style is more in the way we approach a project rather than in how it looks." Part

of that "style" is an emphasis on listening. "If there's one thing I've learned since I opened the firm, it's 'listen.' Listening and asking question help you do many things. First, it helps you determine if you are about to enter into a relationship with an insane person. I like to have two or three meetings with new clients before I even think about putting pencil to paper. I get a lot of information about the project, but I also get a sense of the client's ability to reason and understand. Listening also builds trust. The client tells you something, and you show them evidence that you heard it, understood it and integrated it into your thinking and approach."

Making lists is also part of the Isley approach to design. "We do very little brainstorming in a group. It's usually one-on-one with a designer or a client. I just can't think on the spot. I'm much better with lists. I get really informed at first, and then I write pages and pages of lists. Words, in concepting, seem to be more efficient than images. I can write a word much faster than I can draw it. And words say so much more. We then progress to thumbnails and sketches. We've gotten to a point where we show the client rough sketches before we make a refined comp. Actually, the execution is the hardest part of the project. All that organizing and agonizing and lots of memos with production schedules—that's where something can really blow up on you."

Although a lot of thought goes into every design, Isley still believes creative success starts with good listening. "Listening. That's the big creative surprise. I used to talk too much, but now I let the client do it all."

Can You Be Too Creative?

BE WHAT YOU IS, NOT WHAT YOU AIN´T.

CAUSE IF YOU AIN´T WHAT YOU IS, YOU IS WHAT YOU AIN´T.

Luther D. Price

INSPIRATION COULD BE CALLED INHALING THE MEMORY OF AN ACT NEVER EXPERIENCED.

Ned Rohrem, composer and writer

You can never be too creative. Your job as a creative professional is to develop and present ideas that fit the objectives and approach the problem in a unique way. You can't do this too much. If you do what you were hired to do, and the client does what he is hired to do, the cumulative effect of your both being professionals will result in appropriate decision making. That may mean sometimes gracefully accepting a client's "no" as well as being surprised by a client's unexpected "yes." Creativity is best evaluated by a client and designer who both understand the other's agenda and concerns. The best creativity results from client and designer trusting and respecting each other's roles and opinions.

The real question is not whether you can be too creative, but whether you can overuse style when trying to solve a communications problem. The answer to the latter question is "yes." What people consider to be too creative is often overstyled instead.

A client makes some assumptions when she asks you to help her solve a problem. One major assumption is that you will listen to, understand and integrate the communication objectives into your creative thinking. Another is that all the solutions you present are appropriate for the audience. That means the audience must be able to read and understand the message. If, in the name of style or cleverness, you fail to talk to your audience because you haven't presented the information in a readable and understandable fashion, you've gone too far.

Identifying a Good Idea

What *is* a creative solution, anyway? It's a lot easier to say what it *isn't*:

- It isn't taken from someone else's idea found in a design annual.
- It isn't the blank face or shrugged shoulder of confusion.
- It isn't the result of combining parts of three ideas presented to the client.
- It isn't the latest computer technique, the latest specialty paper or the hottest photographer.
- It isn't trend, technique, style or gimmick.

A good idea communicates immediately. It commands a smile or elicits a tear. A reaction to a good idea is often audible—a sigh, a grunt, a laugh or a gasp. A good idea facilitates consensus or spurs debate. A good idea requires no thought but at the same time stimulates thinking. It makes the client's job easier and the audience's job a pleasure. You know a good idea when you see one: Your gut, brain and heart all react at the same time. A good idea can be articulated while not having to be explained. A good idea generates enthusiasm. It can be happy, angry, calming or violent.

One of the best experiences of my professional career was collecting the responses to a promotional effort sent to clients and colleagues at Christmas. (You can see some of the actual piece on pages 56–57.) The piece communicated an emotional statement on the meaning of family. All the recipients were moved. In fact, most called and thanked us for the Christmas card. Many stated that the card would be stowed away with the Christmas boxes and brought out each year to be read on Christmas. I will never forget the reaction of one client. She was so overcome by the meaning of the message that she could barely speak through her tears. I can't expect an idea to do any more than that. This is the power of an idea, a *good* idea.

> IF COMMUNICATING SOMETHING IN A BORING, MUNDANE FASHION SHEDS NEW
> LIGHT ON THE INFORMATION FOR THE AUDIENCE, THAT IS A CREATIVE SOLUTION.

Can a Creative Solution Look Conservative, Even Boring?

Of course. *Creativity* is simply a fancy way to say you are looking at something differently. You are presenting it in a new way or from a different perspective so the audience will see the information in a new light and understand it better. If the audience is used to seeing things in a flashy, colorful presentation, a boring black-and-white presentation will look new and different to them. In fact, using the latest techniques, images, styles and typefaces can actually be counterproductive to approaching something creatively if you are simply doing what everyone else is.

Although the impact of creativity can be significant from project to project, its presence may not be obvious. If the objective of a project is to make information understandable and accessible, it's likely to appear boring. But if the environment that information appears in is clouded by complex and convoluted information, a plain, direct and understandable presentation will stand out, and can appropriately be labeled as creative.

good idea =

look for the
smile or
the tear

UCLA Summer Sessions Poster and Claes Oldenburg Catalog for Gemini G.E.L.

There are two extremes in creative problem solving. At one end of the scale is a situation in which the subject matter is neutral, and the designer adds the personality. At the other extreme, the subject matter defines the personality of a creative solution, and the design simply frames it. The UCLA Summer Sessions poster falls at the creative expression end of the scale. The Claes Oldenburg Catalog illustrates a situation where reinforcing the content is the paramount role of the creative process. Both pieces were designed by John Coy of Coy, Los Angeles, who is currently pursuing a balance between his own creative expression and his responsibility as a designer to reinforce the content. "Designers are not primarily fine artists. It is important that we not make something so interesting that it gets in the way of the message. Unless, of course, the client (and the reader) insists on it," says Coy.

Such is the case with the UCLA Summer Sessions Poster. "Here is a project that was brought to the studio because of our pursuit of the creative connection. We were given a neutral message and asked

Notebook page #23-78:
Studies for a Sculpture in the
form of a Sneaker Lace, 1978
Pencil, ball point pen,
felt pen, clipping
Collection of the artist

UCLA SUMMER SESSIONS 1994

UNIVERSITY OF CALIFORNIA, LOS ANGELES 90024-1418

to add the personality. The client asked us to 'do whatever' to make something interesting and attractive to the students of UCLA. I wanted to make something that talked to people, nothing too heavy or controversial, just provocative."

Where did this creative expression spring from? "I have notions on the computer, like the mind and how it takes in all this information and just computes the solution. Well, I like to let the media swallow the information and then talk to me. This is often in the form of accidents. I have this dialogue with the computer; it's the same dialogue I've had with a Xerox machine for years. These machines create something I could not have thought of myself; all I do is isolate and integrate it. This poster exemplifies that dialogue."

The Oldenburg Catalog exemplifies the opposite approach. "I worked directly with Oldenburg.

His work needs no one to add personality to it. So, in this case, we framed the subject matter. The sketchbook is so characteristic of Oldenburg. Compared to the standard catalog formats, the sketchbook best represented and framed the subject. The simplicity of the presentation—Courier typeface and the stark layout—emphasized and brought out the personality of the art and the artist. We work with the artists on these catalog projects, honoring who they are, becoming an extension of them and their talent, absorbing their sensibilities. And the client leaves us alone."

It seems that Coy respects creativity, his own and that of others. And he finds a way to communicate a message transmitted through fine art—his own and that of others.

Pushing Ideas

Enhancing the Concept Through Implementation

It's not enough to have an idea. The ideas we generate in brainstorming are only a start. A truly creative design is founded on excellent understanding of a problem, an ingenious approach to solving that problem, and an impeccable execution of the idea. As designers, we must choose among a whole warehouse of design techniques, approaches and tools. We must evaluate endless rules about grids, type, images, color, paper choice and print quality. We balance attention to the minutest detail in the implementation of a project against the big picture agenda of the client (or the audience) to create inspiring design communication.

Remember, the basic design tools transform an intangible concept into a tangible incarnation. They can do much to enhance a concept, but they cannot replace it.

Grid

The grid is a tool that helps you make decisions regarding relationships. Designers have a love/hate relationship with this design tool—the grid is either too restricting, providing little or no freedom, or not restricting enough—facilitating chaos when organization is needed.

As with many issues, the truth is somewhere between the two extremes. Some situations require a grid to help add structure and organization to an unruly heap of text. Some situations demand that you not use a grid at all. I've found that most pieces benefit from a modest application of a grid. Grids don't have to dictate the visual look of a piece, but they can add some subtle visual continuity. I believe that many audiences appreciate the use of a grid without consciously noticing its existence. They appreciate having a little predictability in the organization of the page. Imagine a grid as a tool to add varying degrees of structure to your design:

- The simplest grid helps you define margins and gutters to frame the page.
- Grids can define the location of a single key element on the page such as a headline, page number or image. Other elements can be applied freely on the page.
- Grids can be built intuitively by first arranging the elements on a page using insight, knowledge and experience. Then build a grid around that intuitive arrangement of elements. This new grid will guide the layout of the publication's subsequent pages.
- A tight grid with inflexible constraints can structure your page. Then you can aggressively manipulate elements on the page, pushing the limits of conformity to the grid.

Type

Type is everything in design. It is the message and the messenger. Type can be strong or weak. It can enhance or it can detract from the meaning of the message. It can interpret and influence, translate and transform. Use it wisely.

Many people believe, as I do, that type can indicate whether you're a designer of substance or a designer of style. Look through twenty-year-old design annuals—or any magazine, for that matter—and you'll see both communication driven solely by the style of the time, and communication driven by content. The overall design, but especially the type, of the former looks odd and old-fashioned. The latter also may look somewhat dated, but much will still appear fresh and unique or classic and timeless. You'll see immediately the difference—the power of type when it rises above period stereotypes of style.

Type is a powerful tool with many applications.

Type can organize your content. It is the single most important design element for distinguishing levels of content and the hierarchy of information. It organizes and, creatively speaking, sometimes that's all it needs to do. After you've clarified the organization of the communication with typography, it's not necessary to add further doodads and to style your communication. Let the type speak for itself.

Type can interpret your message. Type facilitates meaning. It can tell your reader which word is important in a sentence, which sentence is important in a paragraph, or which page is important in a publication. Your typographic choices—face, scale, color and readability—build on or strip away the meaning of words on the page.

Type can be word or image. Type, and type alone, can be the image that illustrates the concept. Design budgets are subjected to closer scrutiny now than in the past. This doesn't mean that budgets are necessarily smaller, but they need to make sense to the organization footing the bill. Using type as image can produce a high-quality yet budget-conscious project.

Type as image has become more possible with the advent of the computer. B.C. (Before Computer) you couldn't play with type much or for long without running up astronomical bills at the typesetter. But computers have put type into our hands in the same way paint and brush were given to Michelangelo. Playing with type has become a cost-efficient method for clients to get dynamic communications without the expense of creating images. Designers are painting with type, creating images with type, creating entire publications without any images other than type—and holding the reader's interest without conventional images.

Type controls interest. Your words can be powerful. But the presentation of the words, through typography, will control the audience's ability to hang in there. Typography can turn words

Don't Just Say It. Be It.

Recycled Paper Promotion, Remarque Paper

A new 10 percent post-consumer-waste version of the popular recycled paper named "Remarque" inspired the title "Remarks on Remarque" for a new paper promotion piece. What remained was to develop a conceptual package to accompany it, a way to talk with distinction and intelligence about this project to thousands of sophisticated graphic design professionals and other paper users. This somewhat cynical and easily bored audience was already drenched in an endless storm of paper promotions. They tend to be unimpressed by lavish spending or costly production techniques. They also are aware of the irony of using forests full of trees to produce large-scale, paper-wasting, hard-to-store promotions to tell recycled paper stories.

Todd Lief, a writer and creativity consultant, was asked by designer Dana Arnett of VSA Partners to help communicate the Remarque message. One of his favorite exploratory guidelines—"Don't just say it; be it"—came into play early in this project. Unlike competitors' promotions, "We were determined not to talk about our recycled product in a hard-to-recycle format. Our core idea was that the entire promotion would have a recycled character through-and-through. In that way, our claim of not squandering resources would seem more valid. Start with the recycled paper (the product), stir in a recycled format (the old big little book from the 1940s), include recycled images (from work already done by photographer François Robert), use recycled wisdom (in the form of juicy quotations from a variety of folks, living and dead), speak simply to the subject to respect the reader's time and attention span, and get on with it."

We found a concept that sparked the answer. Her last name, "Marks," suggested we build on punctuation marks, such as question marks and quotation marks, for the solution. This also builds on the structured part of her personality and her writing style. (As for the bright color, we hit pay dirt with a combination of yellow and warm red that she loved.) The idea of using a two-sided card developed during production, when we found that the mark looked much nicer when alone on the small surface of the business card. We therefore chose to split the logo and the information onto the two sides of the card.

Linda Chryle's ability to craft a creative, poetic and emotional mix of words has exceeded my expectations every time I've worked with her over the past two years. She is a story writer, driven by life experience, who must believe in everything she writes. She needed a new identity to begin marketing herself more aggressively. Until this point, most of her work came from referrals.

The two of us sat down and just started to talk. We talked for a couple of hours. Finally she said, "I just want to write. Do we have to keep doing this?" That was it. I wrote the words, Linda Chryle writes on a piece of paper. Then I started pushing the idea further. I think in extremes. If you don't push the concept to its purest form, people won't get it. "Linda Chryle writes. Linda Chryle talks. Linda Chryle lives. And she faxes, too." The words symbolize Linda Chryle. They are direct, complete and practical, yet have a twist. (It's curious role reversal: words written by a designer for a writer who works for designers.)

Two women with the same occupation who have very different personalities. One designer with one approach who creates two unique solutions by plugging into those differences.

into texture (when was the last time you read a legal contract?) or into poetry. The typeface you choose, the size, the leading, and the way you break the text into lines or phrases all influence the meaning of and determine the reader's ability to stay with the communication.

Images

An image is worth a thousand words. Two images are two thousand words, and six images are worth six thousand words. But put those six images on a page, and you might as well stuff six thousand words on it. When was the last time you tried to fit six thousand words on a page? This is too much information for an audience to absorb in the blink of an eye (which is about as long as you have to communicate your message). Fewer, more dynamic images communicate much better than numerous, possibly mediocre ones. There are, of course, exceptions to everything. Some designers have created successful pieces with pages full of images—great images, perfectly arranged, each scaled to reflect its importance.

Images should support the message. If an image doesn't move the message forward, it's not worth the paper it's printed on. An image with no meaning is as bad as a sentence with no meaning. Think of your images as carefully selected words in a sentence, chosen to direct the audience toward understanding.

Images can be applied in many ways. As a matter of fact, the terms used to describe uses for type can be used to describe uses for images.

Images can organize your content. Place images to provide a clear focus for the reader. An image will draw attention before a word will. Carefully considered relationships between images and words will pull your reader through the page in the order and at the speed you intended.

Images can interpret your message. An image can be foreboding or depressing. It can also be light and humorous. It can make the words next to it understandable or confusing. Any image that doesn't influence the message isn't worth using.

Images can be picture or word. Remember the rebus, a fun word/image game you played when you were a child? An image can replace a word in a sentence or a paragraph in a story the same way it does in a rebus. In some cases, photo essays with no text have told the whole story.

Images control interest. An image can simply break the grayness of text, giving the readers a break. Sometimes this is necessary, but don't use an image that's meaningless. You might as well use white space instead.

images support the message

tree

Color

It's impossible to eliminate external influences in decisions on color. The influences for your color choices can be based entirely on combinations you have observed in another setting. I'm entertained by color combinations I find that I would not have imagined. My constant awareness of the colors around me keeps my sense stimulated. I consider it a challenge to use certain colors, just to narrow the field a bit.

Color is probably the single most discussed and criticized aspect of a presentation to a client. Color has impact, meaning and presence. It can influence style and understanding. Color can be predictable or surprising, boring or stimulating. Like all other aspects of design, color choice should be based on stated project objectives. The minute you step away from the objectives when discussing issues of color, you open the door to unmanageable criticism of and decisions about color that can then invade other aspects of the design.

In an effort to focus a presentation on the design concept, I often present ideas and layouts without color. I create the presentation in black and white and supplement it with color swatches to indicate possible applications of color. This forces the discussion to focus on the thinking behind the idea rather than which color is the client's favorite. The swatches of color open the door for discussion concerning color without its being linked to the concept.

I feel that color is the most negotiable part of the project. If a client doesn't like a color choice, I submit alternatives. But I never present the client with an open color book and let him choose the palette. If a client is dissatisfied with the color choice, I probe further to understand the reasoning behind the option. When he tries to articulate what is right or wrong with a color, he often realizes how subjective that reason is. When presented with a rationale based on the project's objectives, he usually decides that the choice is better left to the designer.

Paper

Choose the paper carefully so it will reinforce your communication objectives. The choice of a paper stock has more impact on defining the message than most of the other choices you'll make in the course of designing a project. It's not just the choice of a paper stock that influences the message, it's also what you do to the paper. The characteristics of the materials you use—weight, opacity, color and texture—and what happens to these materials during manufacturing—folding, scoring, perfing and stitching—will either hinder or help the communication's success. Paper can help your concept evolve into more than just another piece of printed matter. Must the piece be rectangular? Should it be a standard 8½ by 11 inches or billboard size? Must you trim the piece conventionally? Can you rip or burn it instead? Don't stop at the usual or expected. Explore alternatives.

color choice should be objective.

Translating Intangible Concepts Into a Tangible Reality

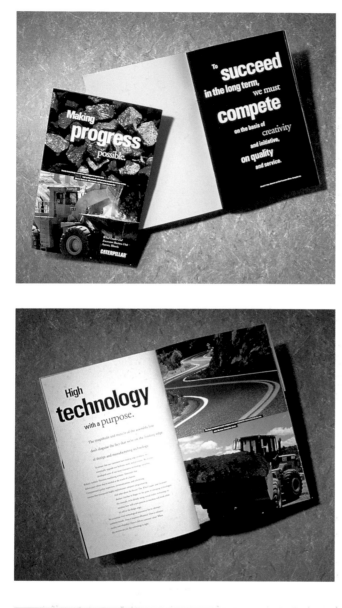

Caterpillar Capabilities Brochure

Caterpillar was working with a consulting firm to help define and communicate its positioning in its marketplace. That positioning is strong in the minds of the customers and public, but the company's communications didn't consistently reinforce it. The consulting firm developed a list of qualities and characteristics that were part of the positioning and established a methodology for communicating those qualities. One of the business units, which manufactures wheel loaders and excavators, asked **Mark Oldach Design** to take these intangible concepts and translate them into a tangible message for its various constituencies. Furthermore, the business unit wanted the brochure to define an image for it. Characteristics of this brochure would be applied to other communications and media to create a unique look for the business unit.

We spent a lot of time getting up to speed on the product and the company. It's a unique product for a unique market. We interviewed a number of employees, toured the facility and researched the market. Ultimately we worked with the consulting firm and the client to hone the message down to "We are a company that enables the world to build a better future. Our machines build roads that carry trucks transporting food that feed people. We lay pipe that carries water and build buildings that shelter people. We build the future."

Photography, color, texture, typography, contrast and grid, all used in a pure form, drove the look we created for the business unit. Each played a role in translating the intangibles expressed in the message into a tangible form.

Photography is a logistical nightmare with machines this size, and it wasn't affordable for this business unit. So we depended on existing product photography to depict the company. We married existing product shots to stock photography depicting the results of Caterpillar work—roads, dams, skyscrapers and landfills. The combination of the two images implies a connection between Caterpillar and the future of the world. The stock photography was chosen based on its impact, texture and simplicity. We made the product photography more powerful through tight cropping and dynamic angling to suggest power and motion.

Broad strokes of simple, pure and strong color fill this brochure, adding impact. (The bright yellow and pure black you see throughout this piece are Caterpillar's corporate colors.) The typography is simple as well. These same two contrasting typefaces are used throughout all of the work we do for this business unit. The faces fall within corporate guidelines for typography, but we push the use of them a bit further. Even the underlying grid dictates a simple and dynamic layout.

Broad strokes of color applied simply are combined with a unique application of typography to create a graphic style that is used for other materials such as videos, a factory display program, a signage program for tours, a diverse series of print communications including banners, and even coffee cups for the vending machines.

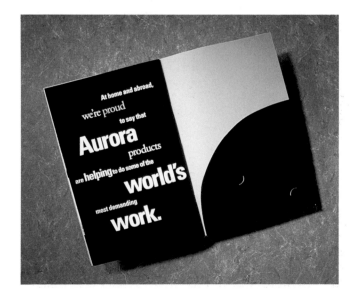

As you consider your choice of paper, think about how your audience will interact with this printed communication.

- Think in terms of function. Will readers keep it or throw it away? Will they frame it, fold it, or put it in a pocket or a file folder?
- Think in practical terms. Do you want the reader to write a response on a postcard in the back or fill out a form? Does the paper need to accommodate handwriting?
- Think about the "voice" of your client. Does the client need to appear socially responsible through the use of recycled papers? Does the client need to appear "classy"? Or "raw"?
- Go beyond what the audience is conditioned to seeing. Does the cover stock really need to be heavier than the text stock? Do the two papers need to be the same paper stock? Does the paper need to be opaque?
- Think in terms of extremes. What if the communication were printed on gloss, bright white, heavy-weight paper? What if it were printed on newsprint or corrugated cardboard?

Now do something with the paper that will enhance your concept.

Printing and Finishing

Too often the designer takes the printing and finishing of a project for granted. Creativity and its implementation don't have to be expensive to produce. But you do need to manage the process for creativity, and you do need to think creatively about how your project might be produced. Look at your variables and decide where you can and can't compromise:

Paper. There's a lot of room to maneuver. Research often uncovers cost-efficient papers that stand up against higher-quality, more costly papers. Specialty and unique papers can also be inexpensive. Newsprint or low-end "workhorse" papers can enhance your communication objectives if considered creatively. Creative design itself can focus attention away from the quality of the paper, drawing attention to other elements.

Color. Less color is not bad. Sometimes I consider it a pleasure to be able to design a piece in one color, rather than have to deal with the meticulous details of multiple-process colors. Think in extremes here, too. If you can't go crazy with a lot of color, look at using only one color. But use it as one color; don't try to imitate a four-color piece by using one color with lots of screens. This will look like a low-budget project. Use the strength of that single color so it works for you—broad strokes of color with lots of empty space and the creative use of type and images.

frame it?

fold it?

pocket it?

file it?

Processes. Sometimes offset printing is not the cheapest method. The lower the quantity, the more offset printing costs. Small quantities can be cost-effectively sillkscreened, labeled, stamped or embossed. Carefully consider the binding, folding and other aspects of assembly. Specialty techniques can draw attention to the communication. I've seen sticks, pencils, rivets and screws set into the binding of books. I've seen chains and twine wrapped around cardboard book covers. I've seen posters with burned corners and tipped-on photographs. These techniques are intriguing, but they should be considered relative to cost, quantity, schedule and, of course, impact.

Here's one last thought, a basic but often ignored one. Discuss production efficiencies, quality concerns, and unique techniques and processes with vendors before the ideas get into your head or the client's hands. Good vendors are valuable resources, willing and anxious to help you.

Quality. This is the last place where you should cut production costs. A piece printed in one color on cheap paper can look nice if it's printed well. But a piece printed at a storefront quick-print shop by someone who knows little about production value can't be saved even if you use six colors, a varnish, and the best paper in the world. Never compromise quality. Quality printing is one of those details that will frame your creativity in a way that the audience, and the client, will notice.

Intuition

YOU DON´T HAVE CONTROL OVER YOUR SUBCONSCIOUS CREATIVE MIND. YOU ARE JUST A
RECEIVER, AN ANTENNA. YOU TAKE IN YOUR WORLD AND TRANSMIT IT AGAIN. YOU ARE
NOT THE CREATOR, YOU ARE THE TRANSMITTER, AND YOU SIMPLY COLOR THE
TRANSMISSION WITH YOUR DISCRETION.

John Coy, Coy Los Angeles

We've looked at the role of traditional design tools in translating a concept into a design. But there are other methods of twisting a conceptual thought or an idea into a tangible piece of creative communication. Intuition is one of the most important of these.

Trust intuition. Believe in instinct, both your own and that of those around you. Intuition is the best resource you have. It is actually composed of experience and knowledge, of insight and vision. Your mental library of experiences and memories opens every time you sit down to design. You remind yourself of what you have seen that truly worked, truly communicated, truly drew emotion or reaction. This is important information. Intuition works on a subconscious level, but it is no less influential in your day-to-day activity. Your work is a product of your experience. If you try to copy someone else's experience, the product will lack passion, rationale and insight.

trust
intuition.

Finding the Not-So-Obvious in the Obvious

Children's Book, Journey: Travel Diary of a Daydreamer

"The process of creativity is so empirical. There is no theory or method. It is unpredictable and uncontrollable and demanding. It's a long process without shortcuts. And it is painful." Guy Billout, illustrator, speaks of the agony of the creative process. "I usually have a starting point. Sometimes it's a theme or a headline that is supplied to me. Sometimes I start with a photograph and begin making associations between the picture I am looking at and the rest of the world. The way they come together is so fickle. I can't articulate it. It just happens.

"The world feeds me in ways I am not aware of. If a picture captures my attention, I trust that. I take pictures of things constantly and save them. Or I see a picture, and I just know something's in it. I don't know what, I just know. So I start with these images and sit and stare at them, sometimes for hours. And the irony just comes. It's a twist of perspective or a stretching of reality. It comes out of what I see, or what I have seen, experienced and read. And it is unexpected."

Billout disagrees with the suggestion that he is meditating and letting his subconscious mind take over. "Quite the opposite," he says. "I put my mind in a trap. I corner it. I focus on a single image until it transforms. How, I don't know. The pictures come to me with more power if I let my mind wander in only the direction it wants to go. If I force the concept with those mind exercises—bringing two irrelevant things together and so on—the process takes longer for me.

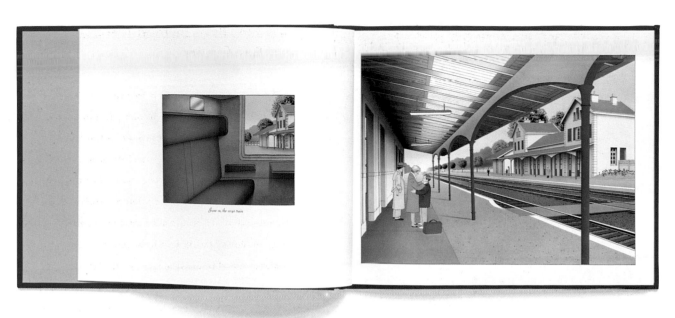

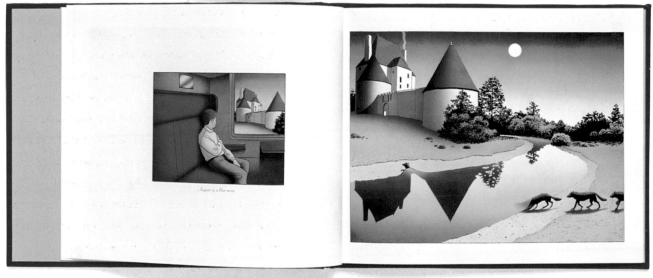

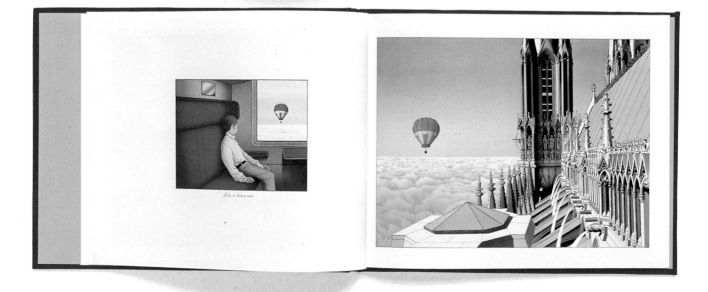

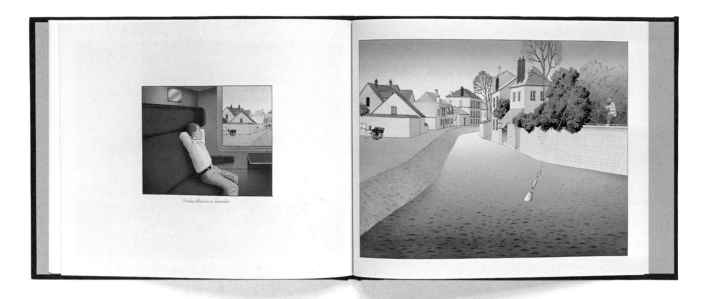

"This process is much easier when I have total freedom. I move from a starting point—a picture, for instance—and gnaw away at the options until I arrive at a very personal perspective." This is what he does for his regular contributions to *Atlantic Monthly* and in the children's book, *Journey*. "I wanted to do a book about a train traveling through different situations. Chris Van Allsburg did a book very similar to that, so I focused mine on the train ride, not the train. The only picture of a train in the whole book is on the cover. The book works on two levels. The macro concept running through the book is a simple one about a boy experiencing the passage of time, getting older, superimposing the meaning of time on each of the micro situations. The micro concepts are the individual situations that the boy observes outside his train window, each a journey across a different surrealistic landscape."

Many visual metaphors that recur throughout Billout's work appear in this book. Icons connect the viewer to possibility. Cliffs, lighthouses, windows, planes, ships, trains, tracks, roads and mountains serve as metaphors for "potential."

The interpretation of Billout's illustrations changes with each viewer. One illustration, a mountain climber who reaches the pinnacle of the mountain to find himself nose-to-nose with a spider hanging by a thread, first appeared in a book on the kingdom of animals. Later it was used in a poster for the Aspen Design Conference on "Success and Failure," and recently it was used to illustrate the concept of research and design in an annual report for Herman Miller. "All of these connections were brilliant, and if I were given any of these themes to start with, the result would have been entirely different. And probably not nearly as appropriate."

I DON'T KNOW WHERE MY IMAGES COME FROM. I JUST CREATE THEM. I LOOK AT THEM
LATER ON, AND IT'S NOT UNTIL THEN THAT I SEE WHAT THEY ARE ALL ABOUT.

Guy Billout, illustrator

Paint your design like an artist paints an image or a musician composes a sonata. Create it by what feels right inside. Don't stop creating until all the elements talk to you in the way that you want them to talk to the audience. The rules of design simply provide you with a place to start. It's up to you to add the personality and substance.

Accidents

One tool of intuition is the accident. Just as a carefully controlled page can enhance understanding and meaning, so can a carelessly uncontrolled page. We've all been influenced by nature and environment. Walking down a path randomly covered with leaves can suggest meaning. Exploring a building with burned walls or peeling wallpaper produces certain implications. Spilled paint, ripped paper, scraps of type are all tools for the greater understanding of a particular message. The trick is to appropriately use accident to imply the right message.

Accident has risen in stature as a style or technique. Deconstructing type, distorting and discoloring, unfocused images that seem accidental are now being deliberately used to communicate an attitude or style. It's valid to use such techniques to implement design, but they must be derived from objective and coexist with meaning, understanding and readability.

Contrast

Contrast enhances the concept and the message. Something pleasant next to something repulsive makes the pleasant look more pleasant. Something small next to something huge looks smaller. Think of black and white, fluorescent color and gray, strong and weak, and right and wrong.

When looking at any design problem, my first inclination is to look at it in its extremes. Imagine the implementation of an idea in extremes, type, size, color, use of image. To start at extremes lets you see the potential before you begin to compromise. You see, the design process is a compilation of a long series of compromises. If, when you begin the design process, you start to compromise right away, to rule out possibilities even before you try them, you'll never realize their full potential.

It's important to push all aspects of the project—concept, style, message, words, type and image—to the extremes before softening and graying the implementation. Compromise will soften the presentation, which can be good or bad. Make sure that the decision to compromise is deliberate and that the presentation will be successful when finished.

ideas come from accidents.

Sweating the Details

The success of any good idea lies in its execution. The successful implementation of a creative idea ensures that the idea is as pure when produced as when it was discovered. The implementation and application of an idea requires the same level of creativity as finding the idea. And the key to creative execution is a keen attention to every detail of a communication.

Therefore, allow nothing to obstruct the audience's reception of the idea. Sloppy execution, bad printing, ill-conceived typography or poor editing all can distract the audience and get in the way of successful communication. This sounds like common sense, but much can be lost during the final hours of a project's development. Constantly remind yourself that no detail is too small to consider. Think of each aspect and detail of the project as a decision point and a creative opportunity.

Success through attention to detail is another way to prove your expertise to the client. You sold the concept, idea and layout. The client is convinced that the solution is appropriate. Continue to reinforce this positive impression by pointing out details of your thought process and the execution. Don't be too modest or too secretive. Let clients know what you're doing—how hard you're working for them. Every time you point to an aspect of the solution and elaborate how it advances the objectives of the project, your client will smile. I guarantee it. It will reinforce your position as a smart, creative thinker—not a bad position to be in.

Looking at the Big Picture

Remember that it is easy to get caught up in the details of a project. This is because the details are easy hurdles to jump. The small issues are manageable to work out. Details of design are fun to play with. But it's easy to get lost in the details at the expense of larger issues affecting the communication. Focusing too much on detail is a form of procrastination and avoidance, a sign of a dysfunctional designer.

Budget and production costs are the area where it's easy to lose sight of the big picture. That's why even the proposal can be a tool for enhancing your concept. Let's say you have a client with a small budget for a project. You know that your design fee will equal what's not spent on printing. Printing is a manufacturing process that costs what it costs—within reason. If you choose to design something requiring high production values and unique printing techniques, that cost will come out of your fees, right? Wrong. Don't put yourself into this position. The value of preparing a proposal or estimate of fees is to separate the decision making for design and printing. Your original estimate should acknowledge the client's low budget, but she should be prepared for the fact that decisions made in the process of development will influence printing costs. Help her understand the big picture—the trade-offs that affect the success of the communication.

Another scenario: A client with no prepared budget wants to develop a communication and asks you to be creative in your approach. He's a reasonable person, but you sense he's not anticipating expensive printing techniques. Not only must you think creatively about the production of the piece, but you must also manage your client's expectations so experimentation, testing or extra proofs can be used to explore options. This is where your proposal and conversations with your client are important.

Your budget, your proposal, sets your client's expectations. If you tell him something will cost $8,000 and, when the project is complete, it costs $10,000, he'll be angry. If you tell him in the beginning that something will cost $10,000, he may not be happy, but you're dealing with a client who hasn't had any idea of cost prior to the conversation. He's more likely to accept the information at this point, rather than after his mind has been fixed on a lower figure. Anticipate all your production needs, and more, in the budget-setting conversation at the beginning of the project, not in a billing debate at the end. With some forethought, you'll come away from the project with fewer bruises. Who knows? You might even be a hero if your project achieves its objectives and comes in under the mondo budget you proposed.

Build into your implementation process a habit of working both micro and macro. Jump between details and the big picture. Evaluate your project on both levels.

What holds these two visions of the project together? The project's communication objectives. There's safety in these objectives. They will help you escape from a hole. More important, the objectives guide you toward a purpose, and that purpose guides you to the design.

Remember the Audience, in Spite of the Client

Is the Design Working?

It is your role as a creative problem solver to help the client make smart decisions, especially decisions affecting creativity. You must help the client make the right decision. You've started helping the client by only showing her those options that you believe work. However, your decisions may be a bit off the mark. So ask yourself if the design works from the point of view of the audience. If neither you nor your client can answer that question objectively, find someone who can help you do so. Try informal market testing or formal market research. Both will help you and your client answer three basic questions:

1. *Does the communication solicit a response?* If the answer is "yes," move to question number two. If the answer is "no," go back to the drawing board. When you don't get a rise out of your audience, you haven't done your job. Lots of things can get in the way of soliciting a response from your audience. Maybe you made some wrong assumptions about them. Maybe you're telling them too much or too little. Maybe your audience is jaded, and you must be more creative to get through the noise. Or maybe you're part of the noise and need to tone it down a bit. If the readers look at your design and look away with a stone face or, worse yet, a yawn, return to Go.

2. *What is the response?* If it's a violent one, you may have a problem. But if the reader smiles, sheds a tear or even just nods, you're moving in the right direction. Many communications ask the reader to respond to the client—call, send in a card or order something. If this is the case, your design solution should build to that ultimate response.

3. *Is it the right response?* Watch the reader. Make sure he interacts with the piece in the desired way. See how long he stays with the piece. Or does he merely skim it? If, after reading the piece, he reacts as the client wants and you planned, that's the right response.

remember
the
reader
!

Managing Client Expectations

The creative process begins and ends with the client. This is unfortunate—not necessarily because clients are bad, but because the creative process should begin and end with the *audience*. But the fact is, the client is the controlling factor in all communications design projects. The success of the relationship between the designer and the client will dictate both the success of and the level of creativity found in the finished design.

We started out by examining the role of the client in the creative process. We discussed how to set client expectations from the beginning. We now need to explore how to sustain those expectations and manage them throughout the process.

Controlling the Decision-Making Process

You've spent a lot of time developing creative approaches to solving a unique problem. You've generated unique ideas, objectively evaluated them, and integrated the best ones into dynamic arrangements. You've combed through the background information and generated your own research to support the resources supplied by the client.

You know the problems to be addressed. The solutions you're about to present are the result of substantial thinking by you and your colleagues. You're confident that the solutions you present are the best effort possible. Be confident with your work, and be able to articulate your thinking confidently and persuasively.

YOU BALANCE ON THE EDGE BETWEEN TWO EXTREMES. ONE EXTREME IS THE DARING,

RISKY AND UNEXPECTED. THE OTHER EXTREME IS TOTAL AND COMPLETE

UNDERSTANDING. THESE TWO EXTREMES SEEM TO BE COMPLETE OPPOSITES,

BUT THEY ARE AMAZINGLY CLOSE TOGETHER.

Maria Grillo, VSA Partners

LISTENING—THAT'S THE BIG CREATIVE SURPRISE. I USED TO TALK TOO MUCH, BUT NOW I

LET THE CLIENT DO IT ALL.

Alexander Isley, Alexander Isley Design

Presenting creativity is an art in itself. Creative designers who are confident and persuasive are the most successful at working with a client. They sustain the integrity of a good, creative idea all the way through the development, approval and implementation processes. Without confidence in your own work, you become vulnerable to bad decision making, intimidation and excuses from your clients and vendors. On the other hand, clients will respond to your confidence, familiarity and knowledge of this project. You know you have the advantage when you can intelligently articulate the rationale and challenge bad decision making. As you do this, remember:

- Always bring the decision-making process back to the objectives and design criteria of the project that were approved by all decision makers. If you have successfully integrated those objectives into your solutions, it's more difficult for the client to challenge the approach.

- Make sure the decision makers are familiar with the objectives and constraints of the project before you present the solutions. A quick restatement of the problem and assumptions that were made going into the creative process helps bring the decision making closer to an objective process.

- Never be defensive in discussing creative approaches. It's better to listen to what's being said about the presentation without comments. *Listen* is the key word.

- Always remind the decision makers of the objectives before you challenge their comments.

- If your solutions are content driven, they're easier to discuss. If your solutions are stylistic, they're more subject to evaluation against personal tastes, likes and dislikes. It's easier to explain your reasoning (objective) than it is to justify your preferences (subjective).

- Search for the core issue behind any concern expressed in the meeting. A concern about a seemingly trivial point may actually conceal a more serious issue, such as appropriateness for the audience or control of the project.

- Accept that some clients will not make intelligent decisions. Know when to back down. But when you do, decide if this is really a client you want to continue to work with. If you're effective in managing the expectations and decision-making process, a client, even a bad one, will generally make good decisions. Remember, you choose to work with

clients as much as they choose to work with you.

- Be aware of and attempt to avoid the major pitfalls in client decision making: committees, uninvolved parties influencing decision making, and a catalog approach to approving design (choosing elements from each direction to be combined into a single design).
- Control the approval process by presenting only options that you want approved.
- Get rid of "The Attitude" (if you have it). Some designers believe they know more than their clients. Some even believe they perform magic. Others believe they're a special class of people. We don't and we aren't. We're professionals, equal partners with our clients. We have a unique point of view because we have a unique skill. This makes us no better than anyone else. You'll enjoy many more creative successes with your clients if you treat them as peers.

WHAT SOMETHING LOOKS LIKE IS THE LAST THING A DESIGNER SHOULD DECIDE.

Alexander Isley, Alexander Isley Design

Creativity Begets Creativity

If you're good at facilitating and implementing creativity for your clients, you'll be looked on by clients and peers as a dynamic designer. Keep your mind on what you're supposed to do as a design professional, and do it effectively and creatively. Learn to talk about what you do dynamically. Like a snowball rolling downhill keeps getting bigger, the more creative work you do, the more creative work you'll get. Clients—good clients—will come to you. Your peers will look at you with respect. The first step is to stop being a follower and become a leader. Don't try to get creativity from something or somewhere else. Creativity is inside you. You and only you can find it. When you do find it, everything else falls into place.

TO KNOW IS TO NOT TO PROVE, NOT TO EXPLAIN.

IT IS TO ACCEDE TO VISION. BUT IF WE ARE TO HAVE VISION, WE MUST LEARN TO

PARTICIPATE IN THE OBJECT OF VISION. THE APPRENTICESHIP IS HARD.

Antoine de Saint-Exupéry, author, Flight to Arras

The following artwork is used by permission of the copyright holder.

Nesnadny + Schwartz: pp. 6-9
© Nesnadny + Schwartz
 Designers: Mark Schwartz and Joyce Nesnadny
 Photography: Zeke Berman

Mark Oldach Design: pp.14-15, 32-35, 56-57, 64-65, 68-69, 96-97, 118-119, 122-123
© Mark Oldach Design: pp. 56-57, 68-69, 96-97
 Designer for pp. 56-57, 68-69: Mark Oldach
 Designers for pp. 56-57, 96-97: Mark Oldach and Don Emery
 Copywriting for pp. 56-57: Linda Chryle
 Copywriting for pp. 96-97: Dave Ormesher
 Copywriting for pp. 68-69: Mark Oldach
 Photography for Midnight p.57: Anthony Arciero
 Photography for pp. 96-97: Closer Look Video Group
© 1990 USG Interiors: pp. 14-15
 Designer: Mark Oldach
 Copywriting: Marlene Marks
 Photography: Allan Short; stock
 Illustration: David Csicsko
© 1994 First Impression: pp. 32-35
 Designers: Mark Oldach, Don Emery, Mark Meyer
 Copywriting: Lisa Brenner, Linda Chryle
© 1993 Andersen Consulting: pp. 64-65
 Designers: Mark Oldach, Don Emery
 Copywriting: Closer Look Creative Group, Andersen Consulting
© 1992 Linda Chryle: pp. 118-119
 Designer: Mark Oldach
© 1992 Marlene Marks: 118-119
 Designers: Mark Oldach, Mark Meyer
© 1994 Caterpillar, Inc.: 122-123
 Designers: Mark Oldach, Don Emery
 Copywriting: Max Russell
 Photography: Caterpillar/Stock

VSA Partners: pp. 20-23, 84-85
© VSA Partners: pp. 20-23
 Art Directors/Designers: Dana Arnett, Curt Schreiber
© VSA Partners: pp. 84-85
 Art Director: Maria Grillo
 Designers: Maria Grillo, Jenniffer Wicss
 Typographers: Maria Grillo, Jenniffer Wiess
 Illustrator: Maria Grillo
 Photographer: Peter Frahm
 Copywriter: Anne E. Celano
 Printer: Triangle Expercolor

Clement Mok Designs, Inc.: pp. 26-27, 46-47
© Clement Mok Designs, Inc.
 Designer: Clement Mok

Concrete Design Communications, Inc.: pp. 38-41
© Concrete Design Communications, Inc.
 Art Director: Diti Katona
 Illustrators: Barry Blitt, 1992 Annual Report
 Jerzy Kocacz, 1993 Annual Report
 Photographer: Ron Baxter Smith, 1993 Annual Report

Petrick Design: pp. 50-53, 90-91
© 1993 Petrick Design: pp. 50-53
 Art Director: Robert Petrick
 Photographer: François Robert
© 1994 Petrick Design: pp. 90-91
 Creative Director: Robert Petrick
 Designers: Robert Petrick, Laura Ress
 Typesetting: Henderson Typographers
 Printing: Hennegan Printing

MIHO: pp. 72-75, 102-103
© Champion International, Stamford Ct., pp.72-75
 Art Director: James Miho
Victory March; Paris 1944 Champs Elysees. The Bettmann Archive Inc,. N.Y.C.

Safari, Photographer: James Miho

A Regatta on the Grand Canal, Francesco Guardi (1712-1793). Metropolitan Museum of Art, New York, N.Y.

Rivers. Barnard Glacier, Alaskan Canadian Border: Photo: Bradford Washburn.

Scandinavia: Danish Tourist Bureau, Edith Wanscher. Den Permanente Copenhagen. Finnish Tourist Bureau, Marjatta Nurmi, Arabia-Nuutajarvi-Finel, Helsinki. Norwegian Tourist Bureau. Bjorn Halling, Sara (Swedish Restaurant Association). SAS Airlines. Flemming Ljorring, Copenhagen. Migrating Reindeer (Lappland) photo: Nils Nisson, Stockholm.

Signs: MIHO

© MOCA L.A.: pp. 102-103
 Designer: James Miho
 Writer: David R. Brown
 Director of Education MOCA: Vas Prabhu
 Safari: Kenya National Parks: P. M. Olinda, Director
 The Honorable Anthony D. Marshall,

Ambassador, Nairobi Kenya
The Honorable Joseph A. Z. Murumbi, Nairobi Kenya
Amboselli National Park: Joseph Kioko, Chief Warden
Masai Mara Reserve: Simon Tipis, Chief Game Warden
Samburu Game Lodge: Joseph N. Salaon, Game Scout
Serengeti National Park: David Babu, Chief Park Warden
Tsvo W. National Park: Ted Goss, Chief Park Warden
Lamu Museum: James Deveere Allen, Director
Museum of African Art: Eliot Elisofon Archives. Warren Robbins, Director
Musee de L'Hommme, Paris
Field Museum of Natural History, Chicago

Modern Dog: pp. 78-79
© 1993 Modern Dog
 Art Directors: Jeri Heiden
 Designer/Illustrator: Randall Kennedy

Alexander Isley Design: pp. 108-109
© Alexander Isley Design
 Art Director: Alexander Isley
 Designer: Melinda Beck

COY, Los Angeles: pp. 112-113
© 1994 John Coy, pp. 112-113
 Designers: John Coy, Albert Choi
 Illustrator: John Coy
 Typographers: John Coy, Albert Choi
 Printer: Navigator Press
 Separator: Andersen Typographics
© 1991 Claes Oldenburg and Gemini G.E.L, pp. 112-113
 Claes Oldenburg Catalog

Todd Lief for VSA Partners: pp. 116-117
© Potlatch Corp.
 Creative Directors: Dana Arnett, VSA Partners, Todd Lief
 Copywriting: Todd Lief
 Designer: Dana Arnett, VSA Partners

Guy Billout: pp. 126-129
© Guy Billout
 Designer: Rita Marshall for *Journey, Travel Diary of a Daydreamer*
 Art Director: Etienne Delessert for *Journey, Travel Diary of a Daydreamer*
 Illustrator: Guy Billout
 Art Director: Judy Garlan for *The Atlantic Monthly*